MW00634008

Seasons of Lancaster County

HOME TO THE WORLD'S LARGEST AMISH COMMUNITY

Don Shenk

SCHIFFER
PUBLISHING

4880 Lower Valley Road • Atglen, PA 19310

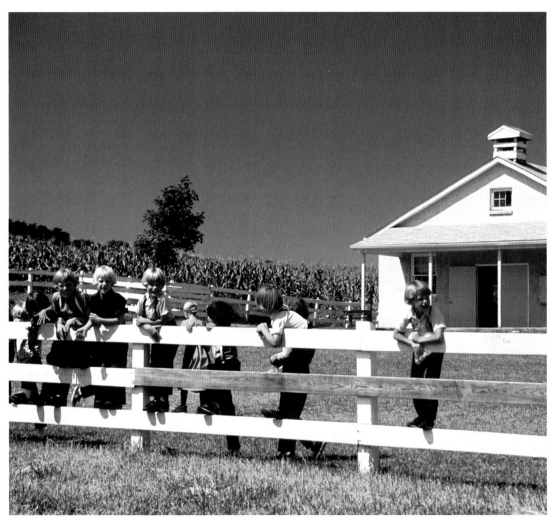

Nickel Mines West Amish School, circa 1990. This was nearly sixteen years before "the Happening" occurred. The school was torn down shortly thereafter.

DEDICATION

I dedicate this book to the memory of "the Happening." This is how the Amish refer to the horrific tragedy that happened in 2006 at the West Nickel Mines Amish School. On that beautiful October day, a lone man entered the school and shot ten female students. Five of the young girls were killed.

As a Christian, a first responder, and a photographer, this event had an impact on my life. Through the years, I have seen my share both of tragedy and miracles as I have responded to emergency incidents. My photography involves a lot of the Amish community, whom I respect highly for their family and work ethics. "The Happening" brought all of these emotions together. As the news was reported, I immediately knew where this was, and could not forget the image I captured in happier times around 1990. I felt as one with the Amish, as well as the responders, and prayed for them. It was an emotional time for me.

The Amish astonished millions when they declared their forgiveness toward the shooter and his family. This was nearly unbelievable and made headlines across the world. How could they forgive this individual?

To the Amish community, it was an expression of their faith. They were simply following scripture that says, "For if you forgive other people when they sin against you, your Heavenly Father will also forgive you" (Matthew 6:14, NIV). What a great example for us all to follow.

Copyright © 2019 by Don Shenk

Library of Congress Control Number: 2018959398

All rights reserved. No part of this work may be reproduced or used in any form or by any means—graphic, electronic, or mechanical, including photocopying or information storage and retrieval systems—without written permission from the publisher.

The scanning, uploading, and distribution of this book or any part thereof via the Internet or any other means without the permission of the publisher is illegal and punishable by law. Please purchase only authorized editions and do not participate in or encourage the electronic piracy of copyrighted materials.

"Schiffer," "Schiffer Publishing, Ltd.," and the pen and inkwell logo are registered trademarks of Schiffer Publishing, Ltd.

Cover design by RoS
Type set in Montserrat & Mrs Eaves

ISBN: 978-0-7643-5755-8
Printed in China

Published by Schiffer Publishing, Ltd.
4880 Lower Valley Road
Atglen, PA 19310
Phone: (610) 593-1777; Fax: (610) 593-2002
E-mail: Info@schifferbooks.com
Web: www.schifferbooks.com

For our complete selection of fine books on this and related subjects, please visit our website at www.schifferbooks.com. You may also write for a free catalog.

Schiffer Publishing's titles are available at special discounts for bulk purchases for sales promotions or premiums. Special editions, including personalized covers, corporate imprints, and excerpts, can be created in large quantities for special needs. For more information, contact the publisher.

We are always looking for people to write books on new and related subjects. If you have an idea for a book, please contact us at proposals@schifferbooks.com.

Contents

Introduction

Lancaster County is located in South Central Pennsylvania. It features four distinct seasons: spring, summer, fall, and winter. Each season holds a beauty of its own.

As one season evolves into the next, it is not a sudden change correlating to a date on the calendar. Rather, over a period of several weeks, the subtle signs of change make us aware that we are entering a new season and leaving the old behind. For example, Lancaster County has experienced snow as early as October and as late as April. A snow scene may "say" winter even when the calendar indicates that it is fall or spring.

Therefore, as you peruse the images in this book, be aware that they may not adhere strictly to the dates traditionally associated with the seasons. Instead, what is presented is representative of the season in which it appears.

Lancaster County has well-preserved historical sites, incredibly rich farm land, and the largest, best-known Amish community in the world. Lancaster City was one of the earliest inland cities in the nation and was capital of the United States for one day. For these and other reasons, it has become a tourist destination for thousands who come to partake in the area's beauty.

A cliché often becomes a cliché because it contains truth. This is true of the phrase "A picture is worth a thousand words." In that respect, we will allow the images to speak for themselves, with minimal comments.

Enjoy your journey through the seasons of Lancaster County as we begin with spring.

Spring

As the winter's chill and snow melts away and spring arrives, thoughts turn to resurrection, new life, renewal, rebirth, and growth.

Spring is a time to enjoy the warmth and longer days, and to await the smell of blossoms, freshly turned earth, and yes, even fertilizer. It is a time to plant and cultivate a good harvest.

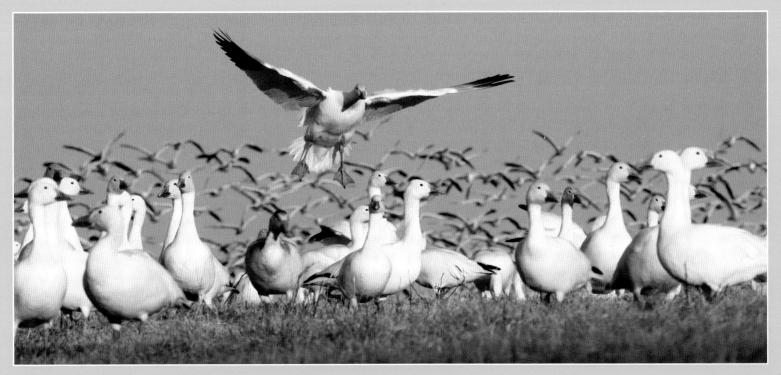

Each early spring in northern Lancaster County, tens of thousands of migrating snow geese and swans arrive at Middle Creek Wildlife Management Area.

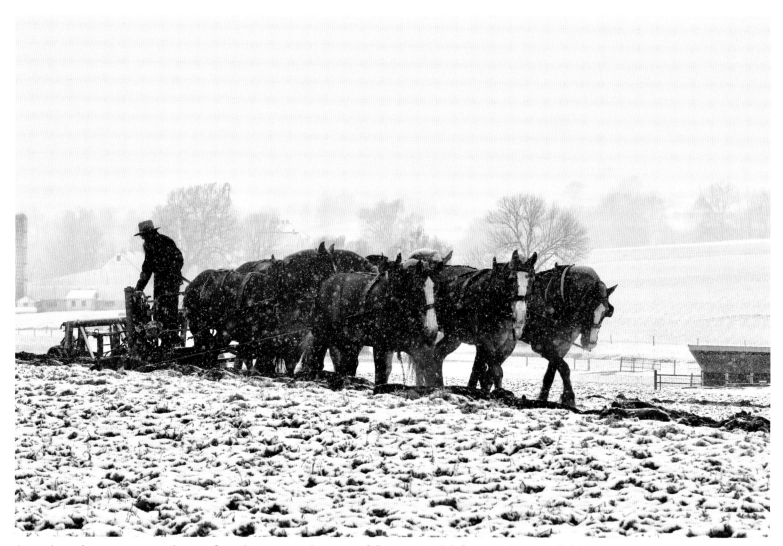

An early-spring snow, sometimes referred to as an onion snow, falls as an Amish farmer plows his field.

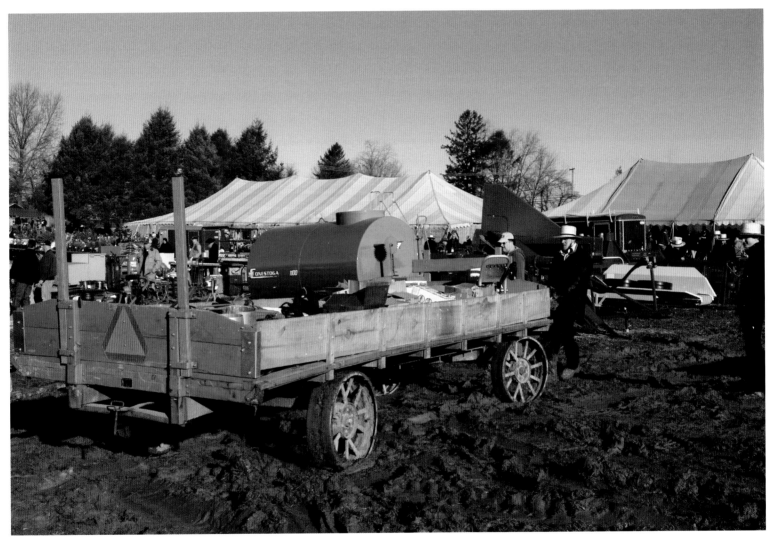

Mud sales are held by various volunteer fire companies as fund-raisers in early spring.

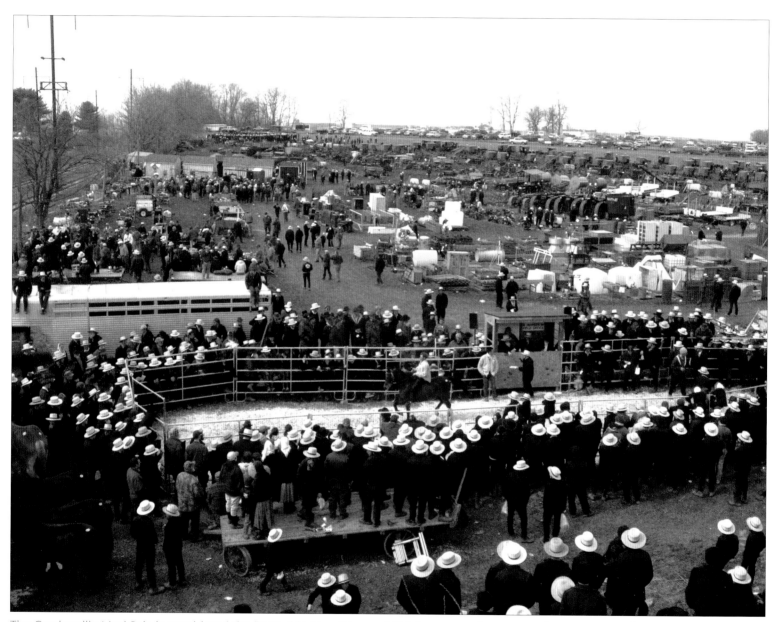

The Gordonville Mud Sale is considered the "Granddaddy of them all." Visitors come from several states to partake in the auctioned goods and delicious food.

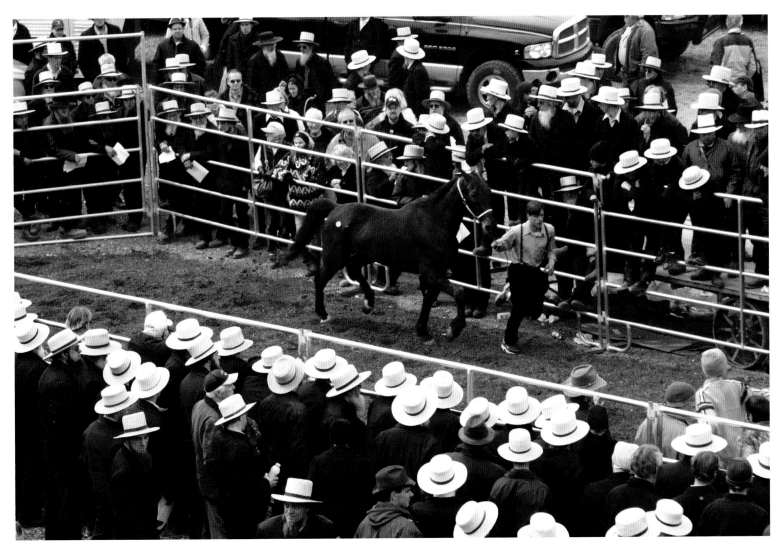

The horse auction is an entertaining part of the Gordonville sale.

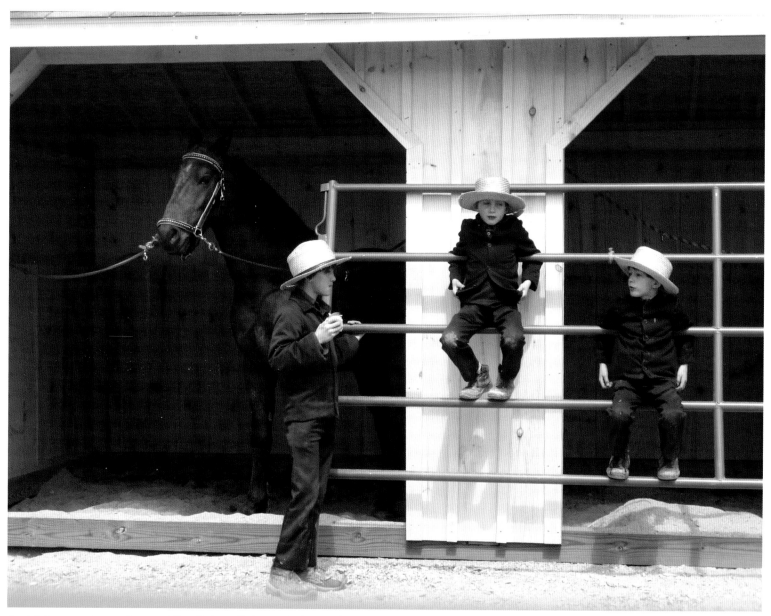

Amish boys rest on a fence at the Robert Fulton sale in southern Lancaster County.

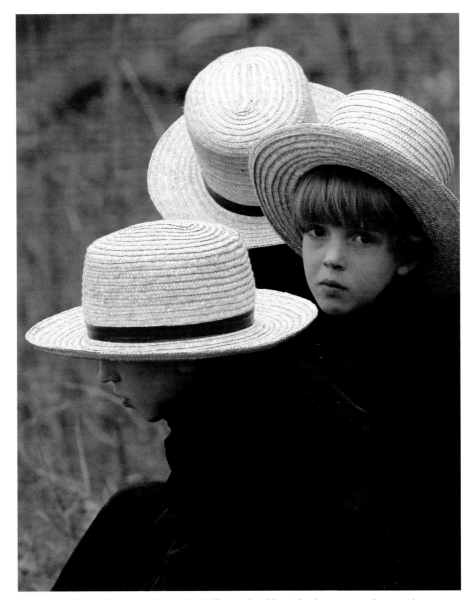

A group of Amish boys sit on the hill overlooking the horse auction at the Gordonville Sale in eastern Lancaster County.

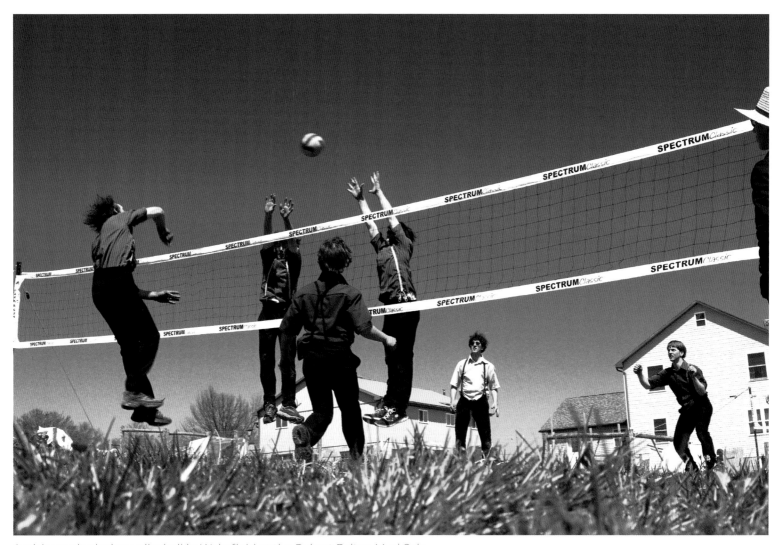

Amish youth playing volleyball in Wakefield at the Robert Fulton Mud Sale

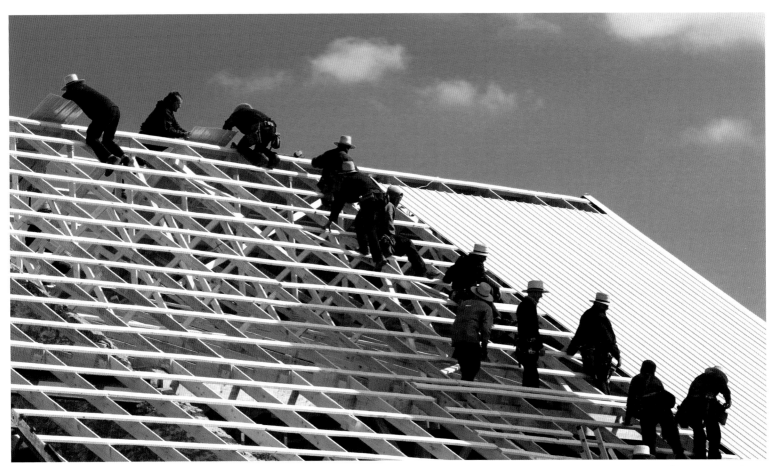

A barn raising in eastern Lancaster County. A rare spring tornado ripped across the area, destroying many structures. The community comes together to help rebuild.

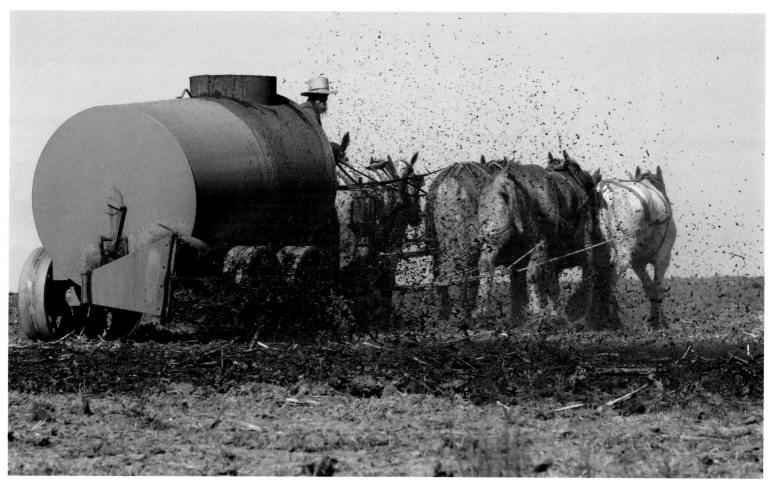

Liquid manure is spread on the fields as fertilizer in preparation for planting crops.

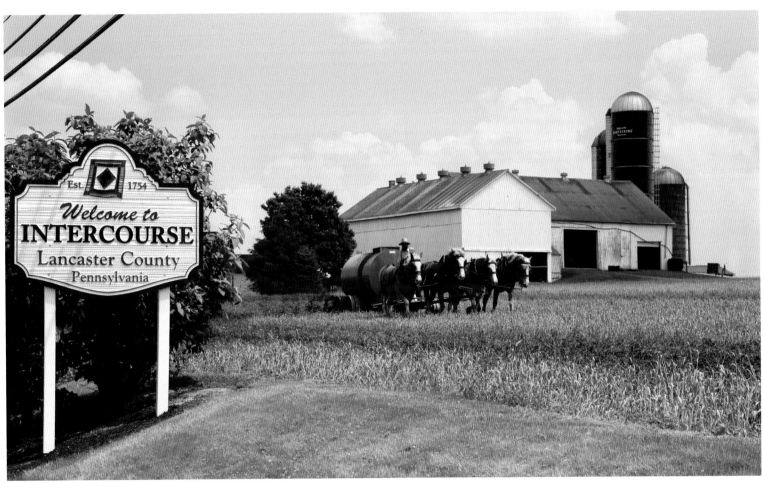

An Amish farmer applies fertilizer to his field just outside the village of Intercourse.

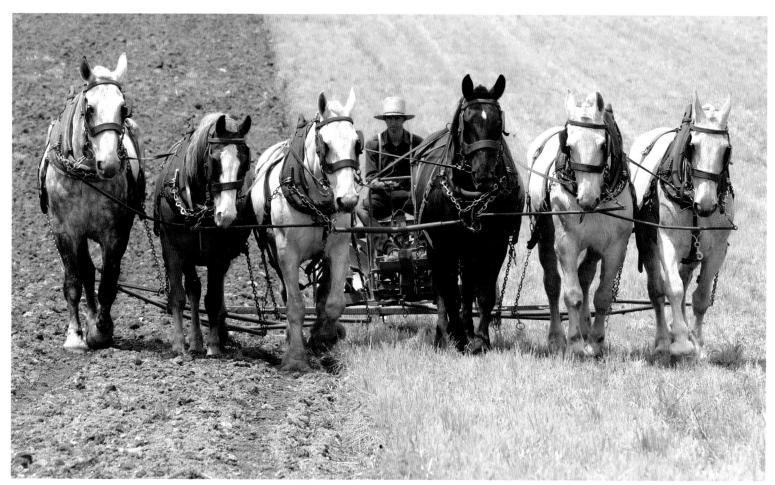

Plowing the field, a common sight in Lancaster County

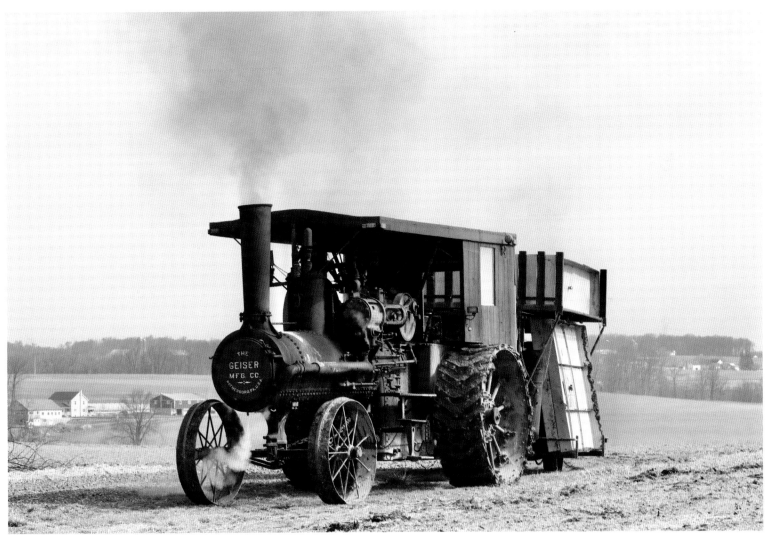

A steam engine leaves the field after steaming the soil before tobacco seedlings are planted.

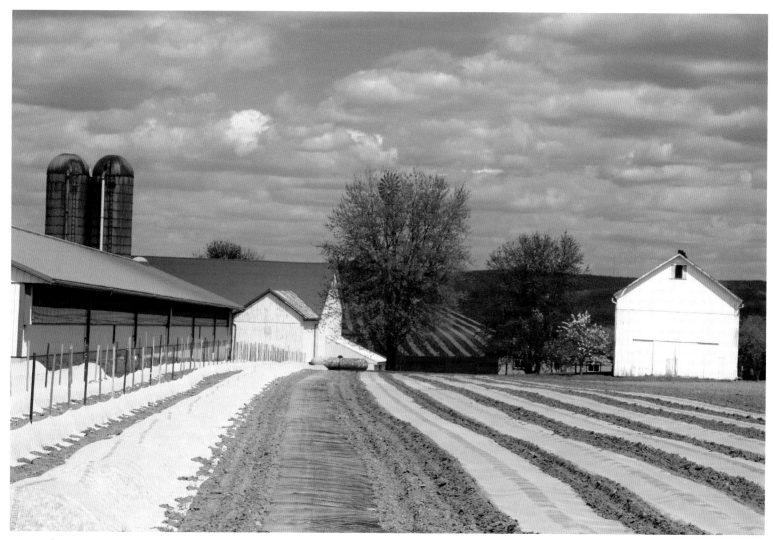

Rows of vegetables are covered, both to protect the plants during cold early-spring nights and as a way to control weeds.

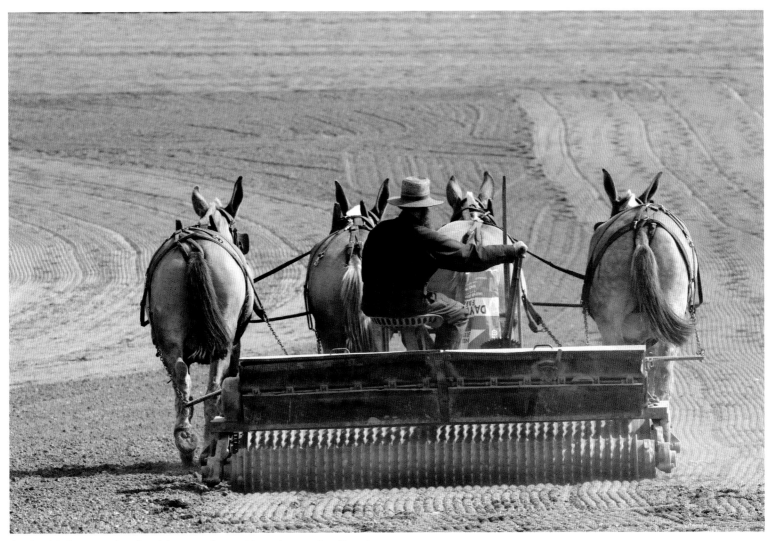

An Amish farmer planting his crops in southern Lancaster County

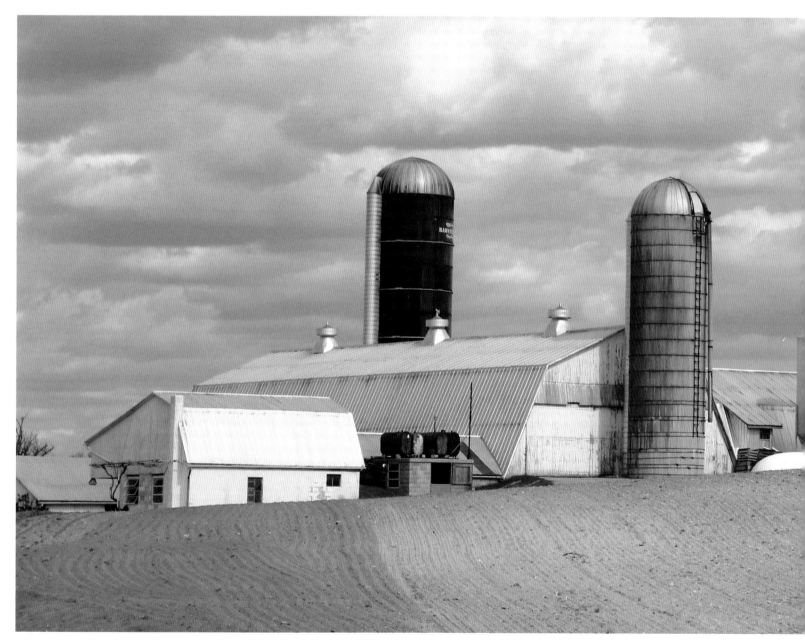

A freshly planted field on a gorgeous spring day

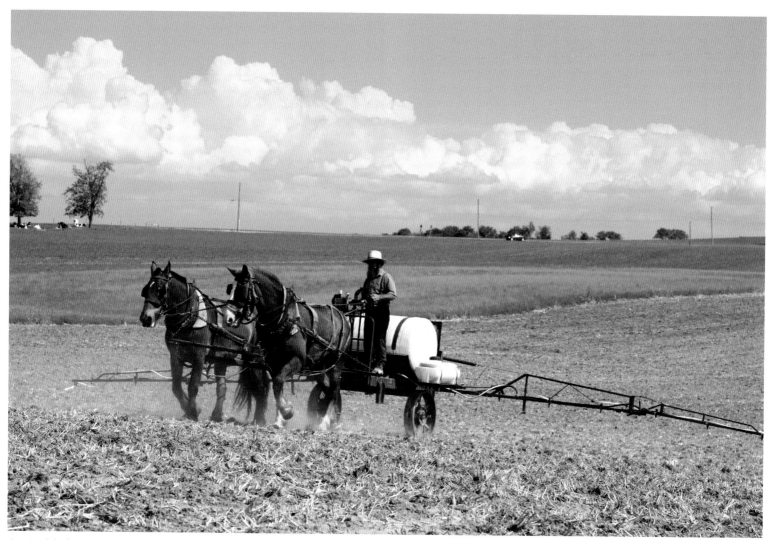

An Amish farmer sprays his field in preparation for planting a new crop.

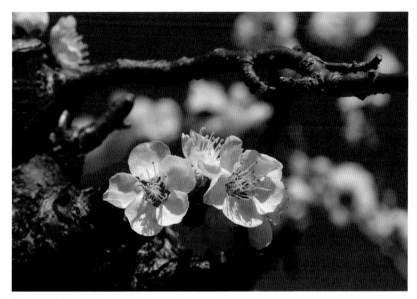

Apricot blossoms

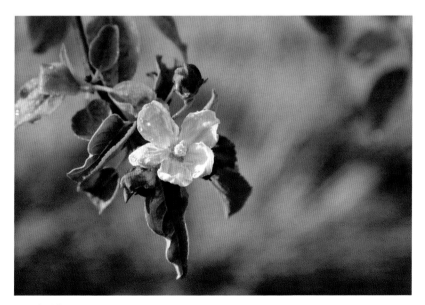

Apple blossoms

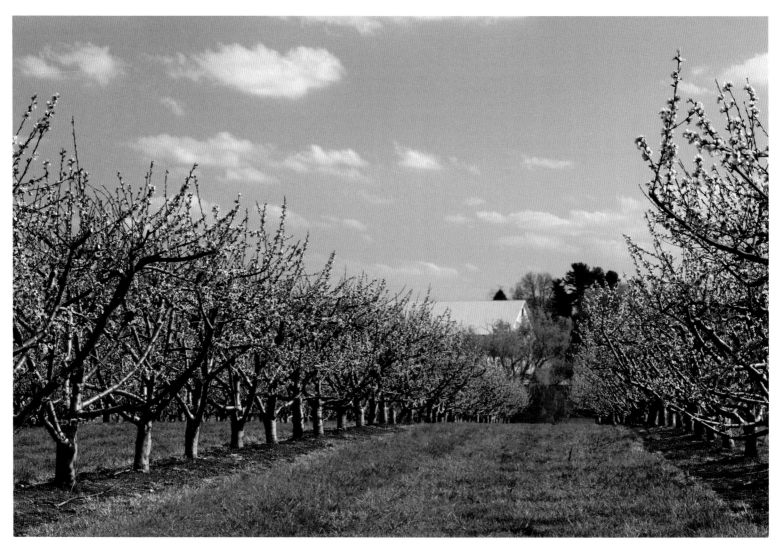

Peach blossoms at a picturesque orchard located south of Lancaster

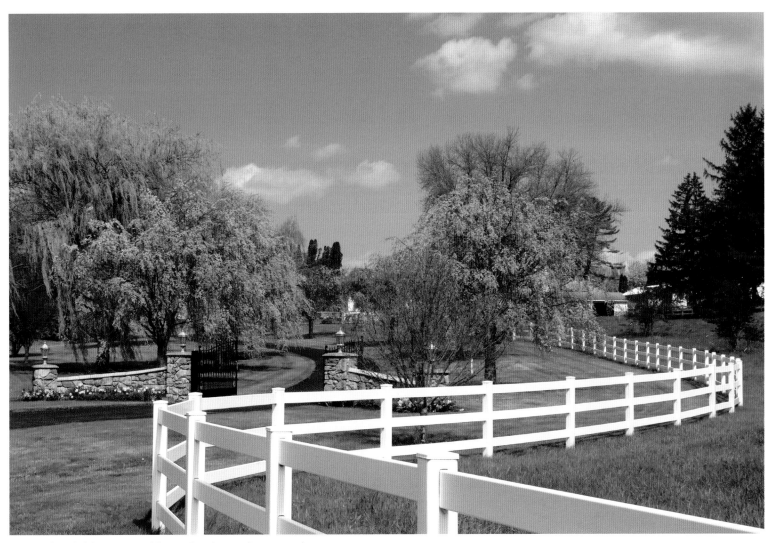

A tree-lined driveway and fence leads to a farmstead.

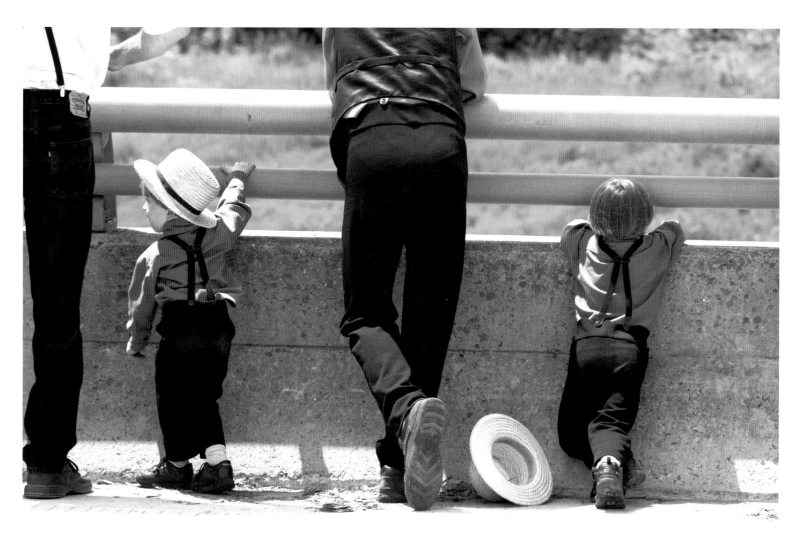

Every May, the local "Make a Wish" truck convoy travels from Lancaster to Ephrata and back. Thousands come to watch, including those shown here viewing it from an overpass.

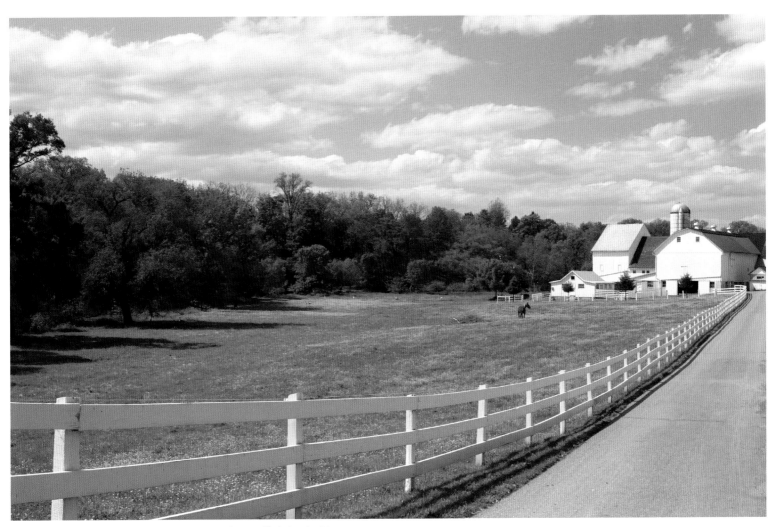

A farm located north of Lancaster on a beautiful day in May

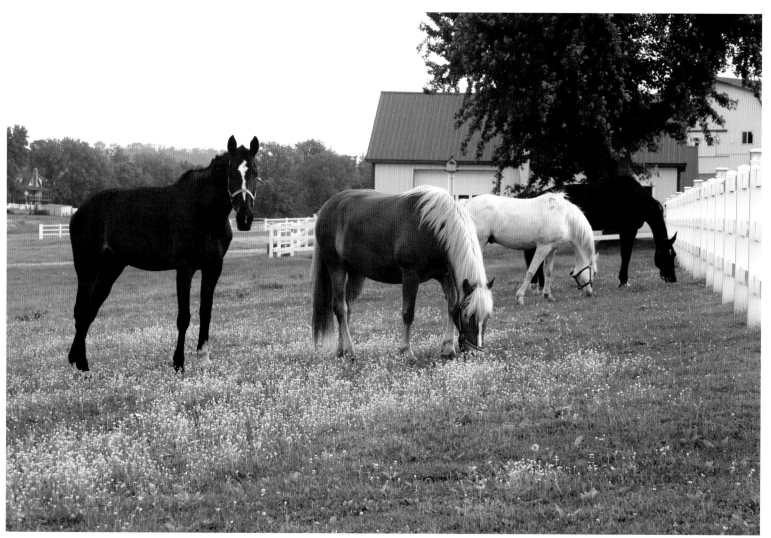

Horses graze in a buttercup-filled pasture in eastern Lancaster County.

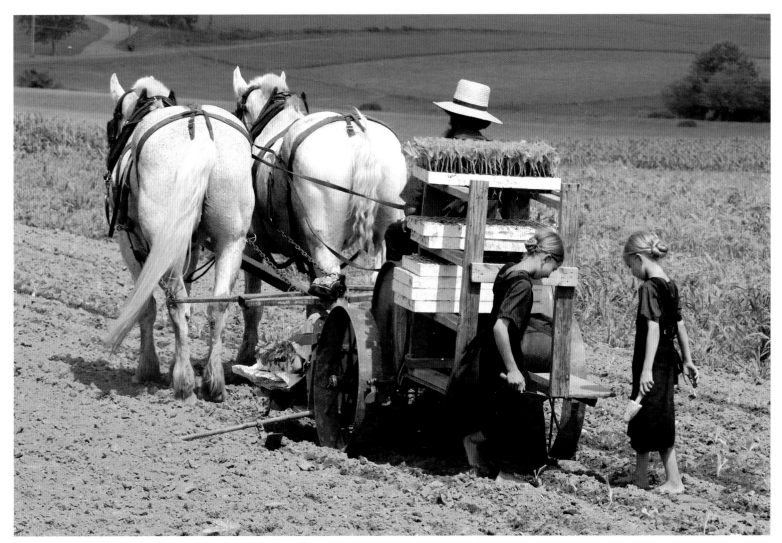

Amish girls follow behind a tobacco planter, hand planting in spaces the planter misses.

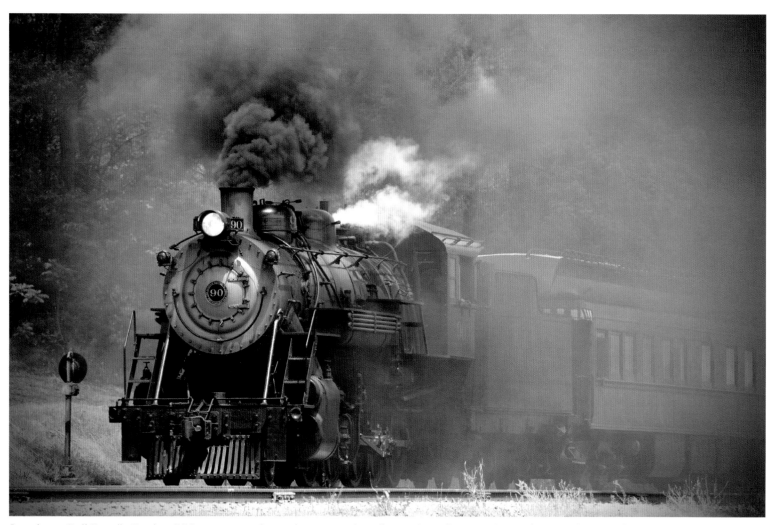

Strasburg Rail Road's Engine #90 spews smoke and steam as it pulls a string of restored wooden coaches on the return trip to the East Strasburg station.

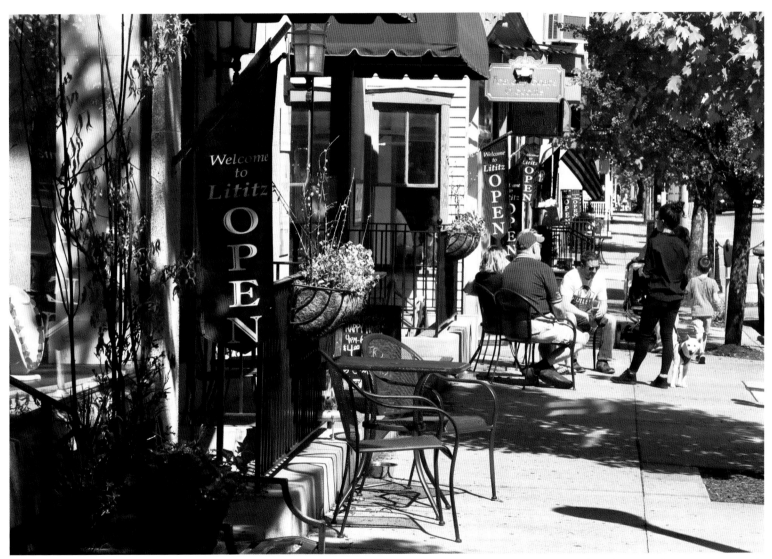

Lititz has the distinction of being voted "the Coolest Small Town in America." It lives up to this honor with its history, shops, events, and eating establishments.

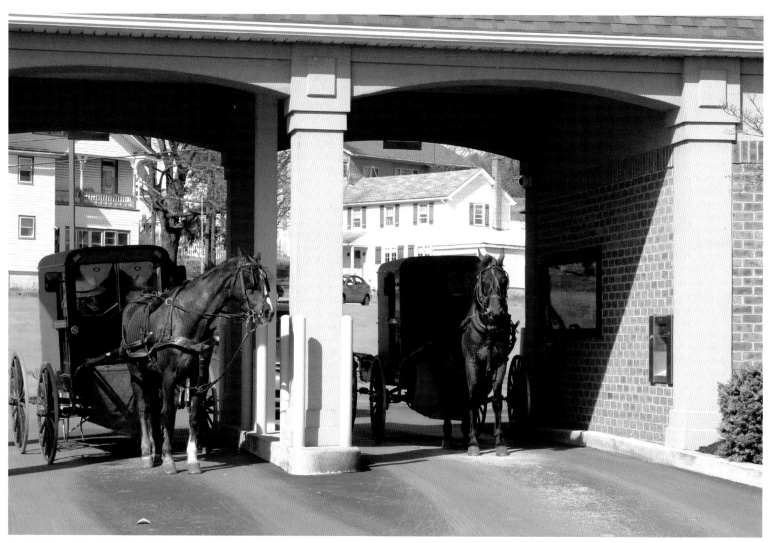

Amish buggies occupy both drive-through lanes of this bank in Georgetown.

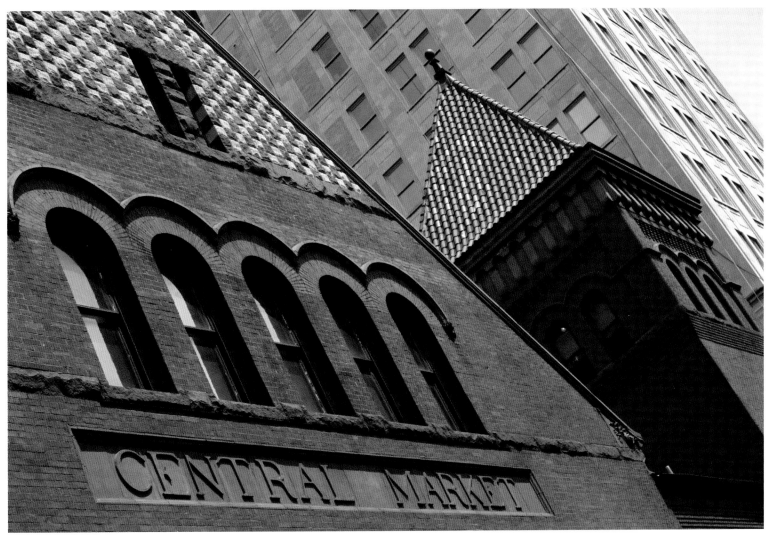

Historic Central Market in downtown Lancaster is the oldest continuously operating farmers market in the United States.

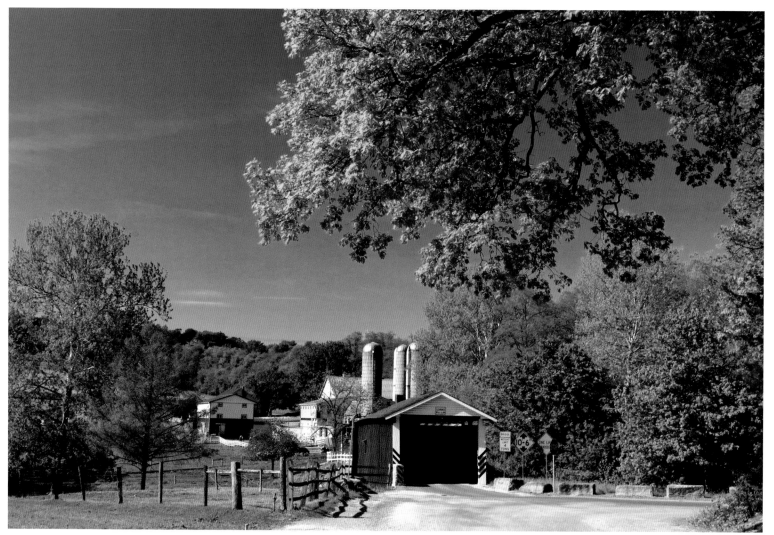

Jackson's Mill Covered Bridge is located in southern Lancaster County and is one of many covered bridges still in use.

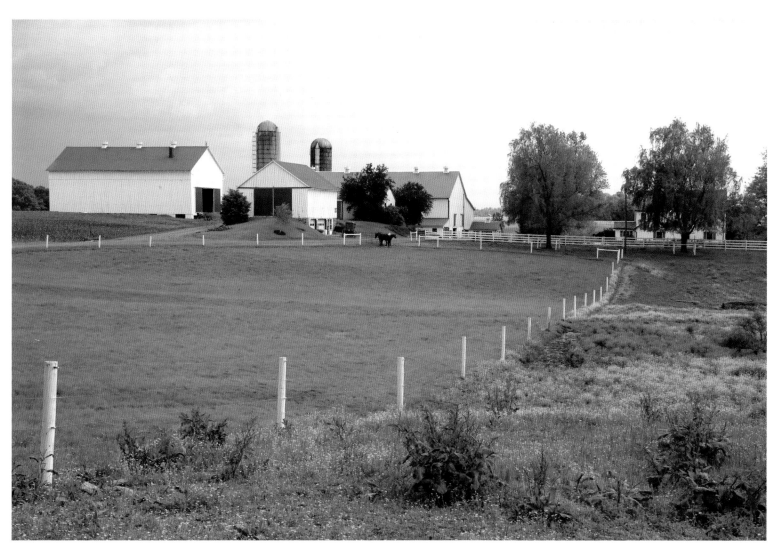

An Amish farm in eastern Lancaster County

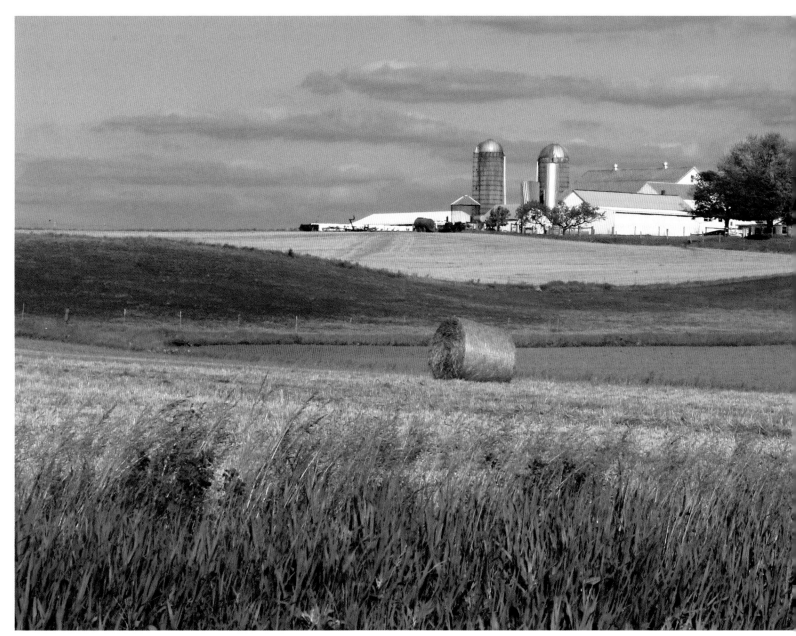

A farm with hay bales

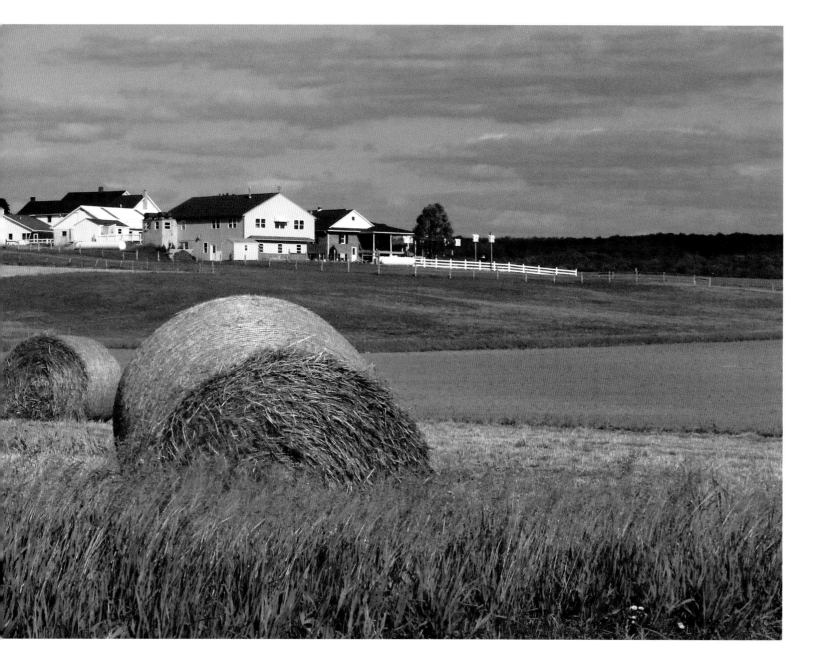

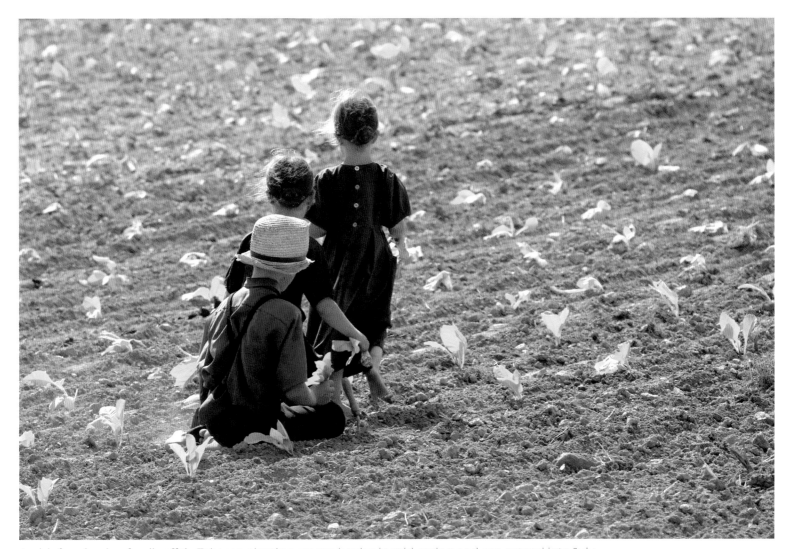

Amish farming is a family affair. Tobacco planting season begins in mid-spring and can extend into July.

Summer

As spring evolves into summer, the days become noticeably warmer and often quite hot.

Fresh fruits and vegetables are plentiful at markets and roadside stands located throughout the county. Harvest time begins in earnest.

It is a time to go barefoot, swim, go on a picnic, or take a vacation.

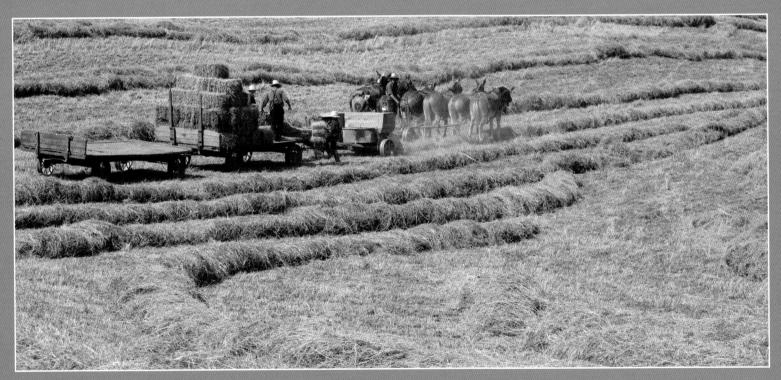

Amish farmers harvest the first cutting of hay on an early-summer day in the rolling hills of southern Lancaster County.

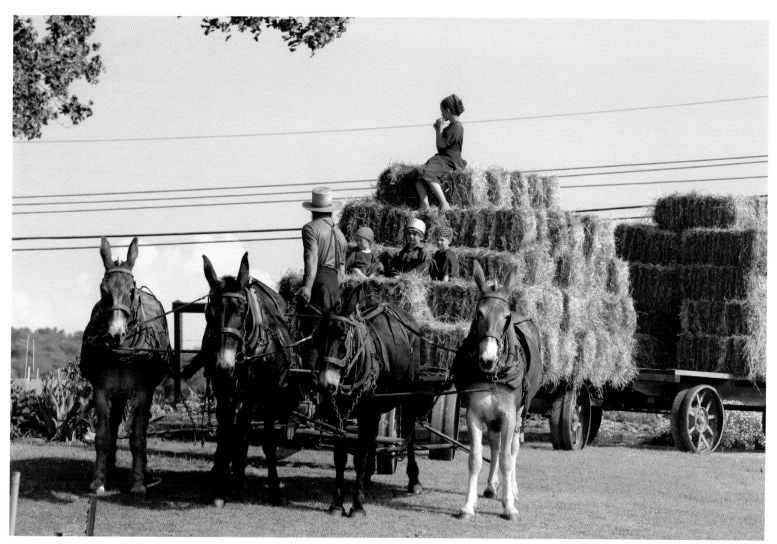

An Amish farmer delivers his loads of baled hay to be unloaded in his barn. His children enjoy a private hayride.

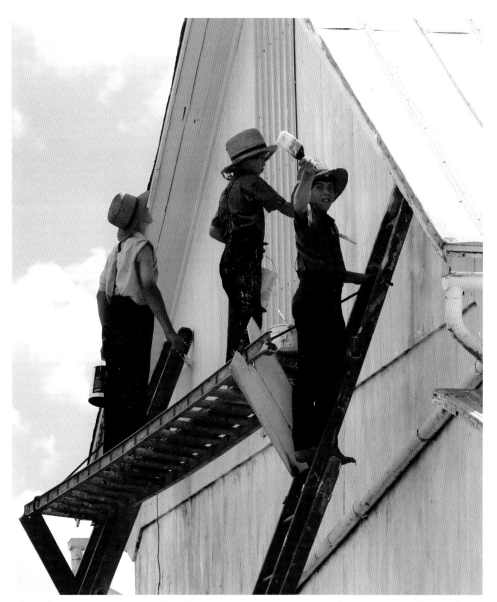

After the crops are planted and before harvest time, there is an opportunity to do some maintenance on the buildings, such as painting the barn.

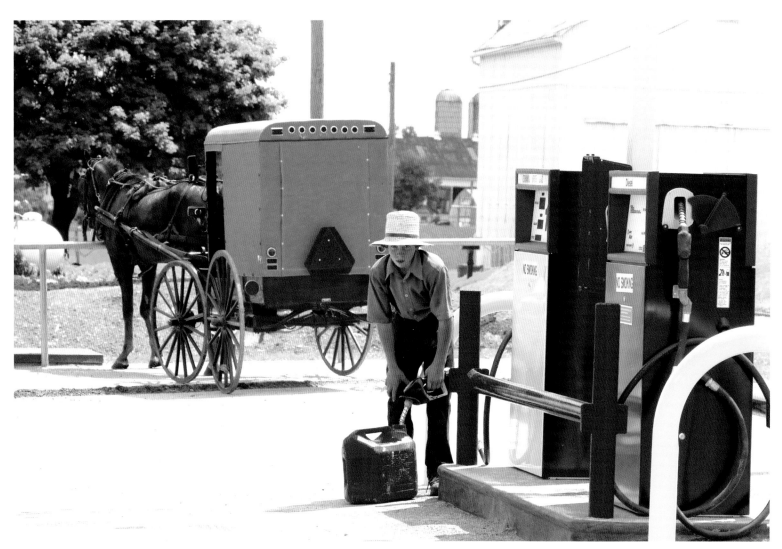

Many farm implements and tractors are powered by gas or diesel fuel.

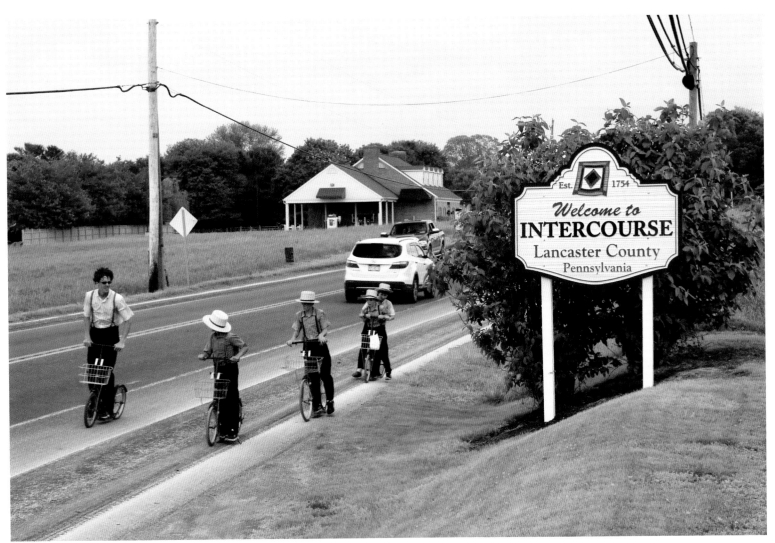

After attending a community event in Intercourse, these Amish lads head home. Scooters are a common form of transportation in the Amish settlements.

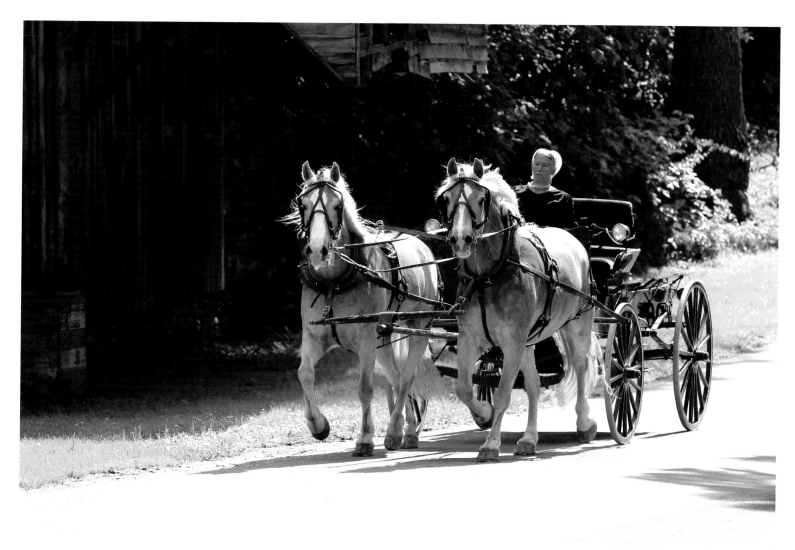

As evening approaches, an Amish lady guides her spring wagon along a rural road. Generally, a double horse hitch suggests a long trip or heavy load.

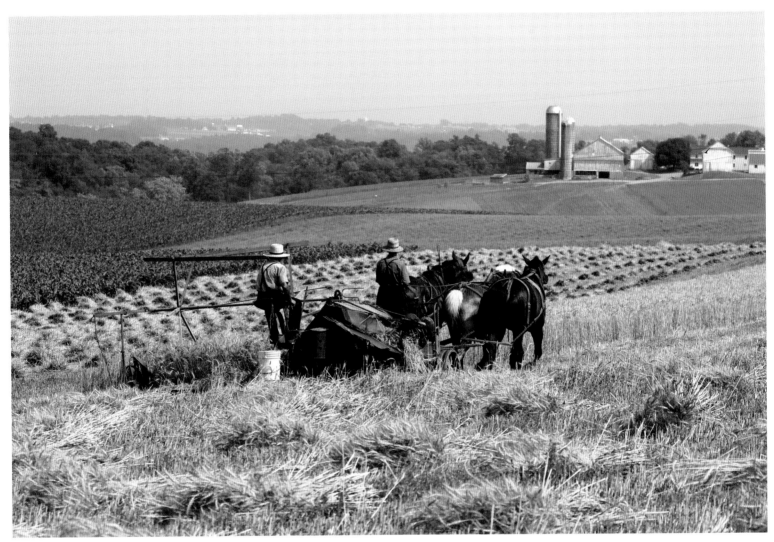

Amish farmers cut their wheat crop on a warm summer day.

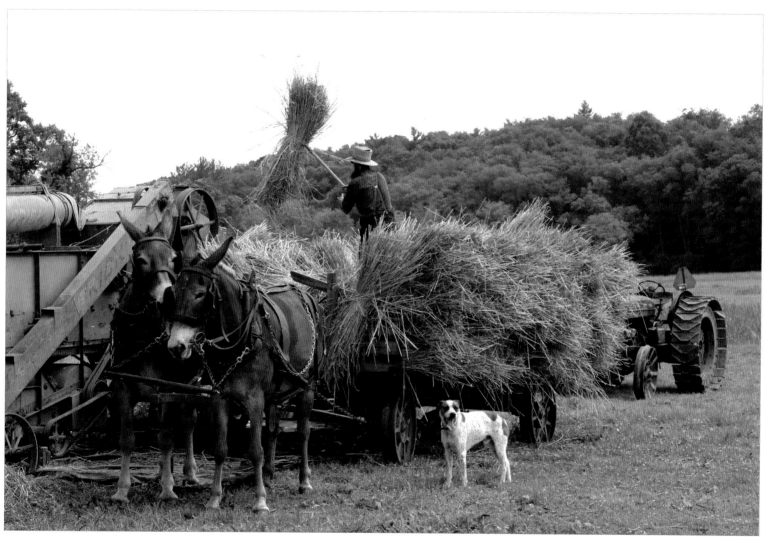

Wheat is loaded and taken to the threshing machine, where the grain is separated from the straw. The straw is then baled and stored in the barn for use as cattle bedding.

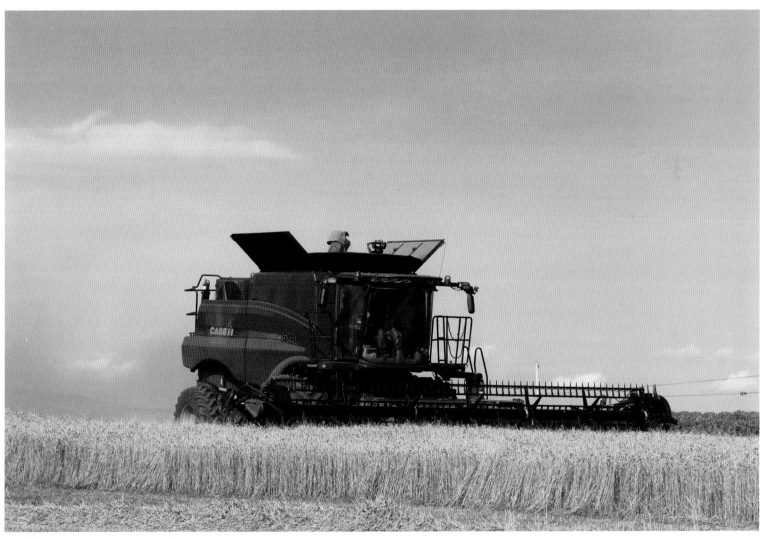

The "English," as the Amish refer to non-Amish, use modern combines to harvest grain.

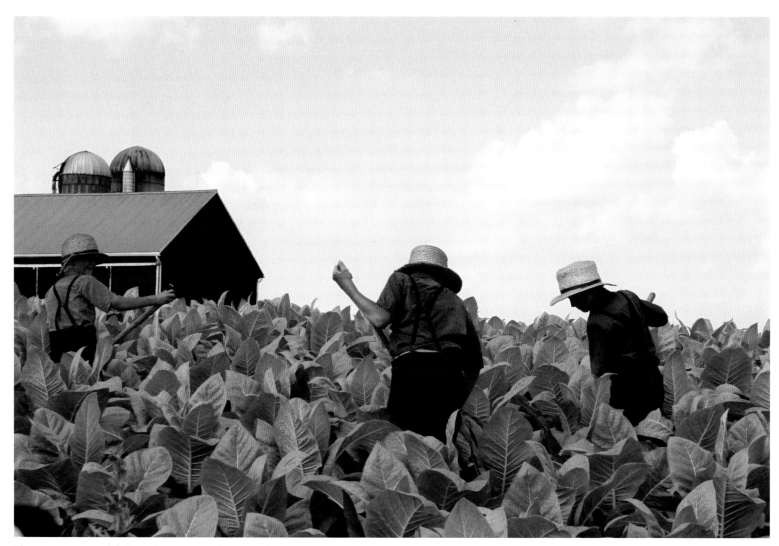

Three young Amish boys hoe weeds in the tobacco crop.

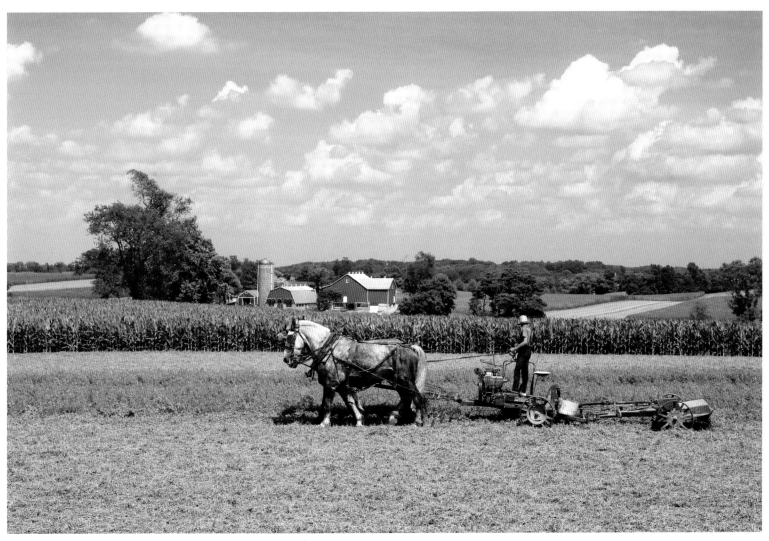

An Amish farmer uses horsepower to pull his mower/crimper.

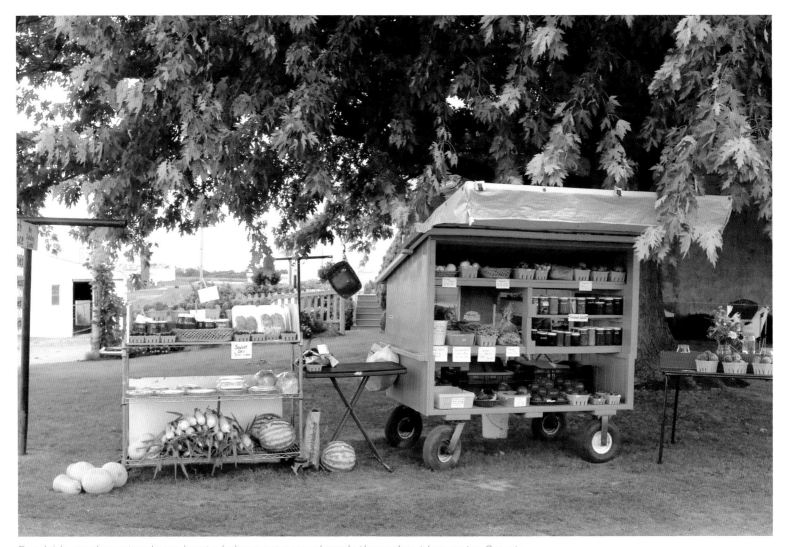

Roadside produce stands are located along many rural roads throughout Lancaster County.

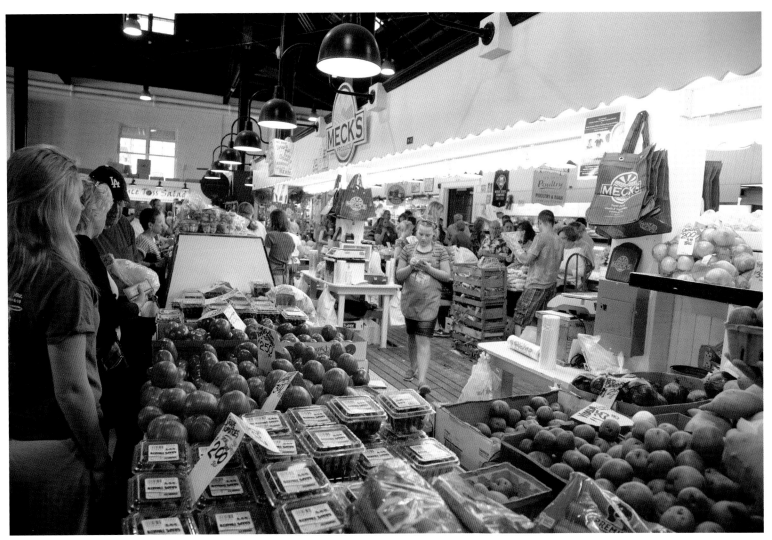

Lancaster's well-known Central Market is open three days a week in downtown Lancaster. During the summer months, it features lots of fresh vegetables, along with flowers, baked goods, crafts, and ready-to-eat foods.

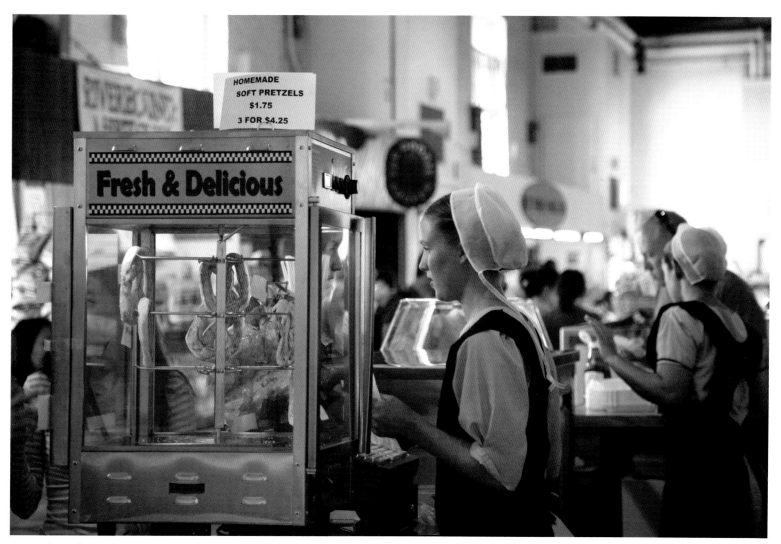

A number of stands at the Central Market are owned and operated by the Amish.

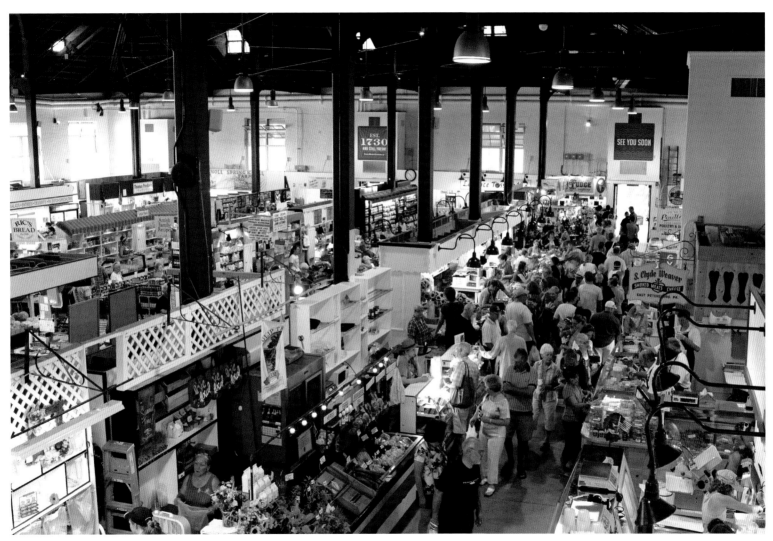

An overhead view of Central Market, which becomes crowded during busy hours.

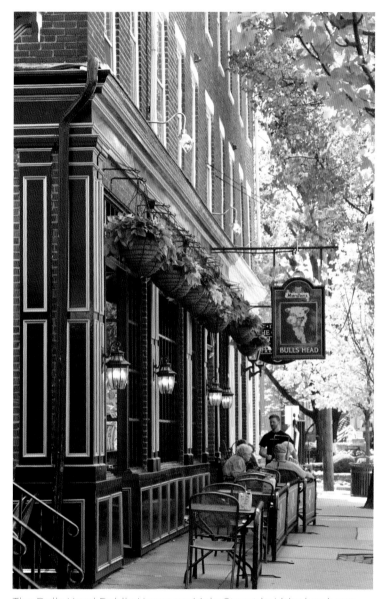

The Bulls Head Public House on Main Street in Lititz has been named the country's "Best Beer Bar" by the readers of *USA Today.*

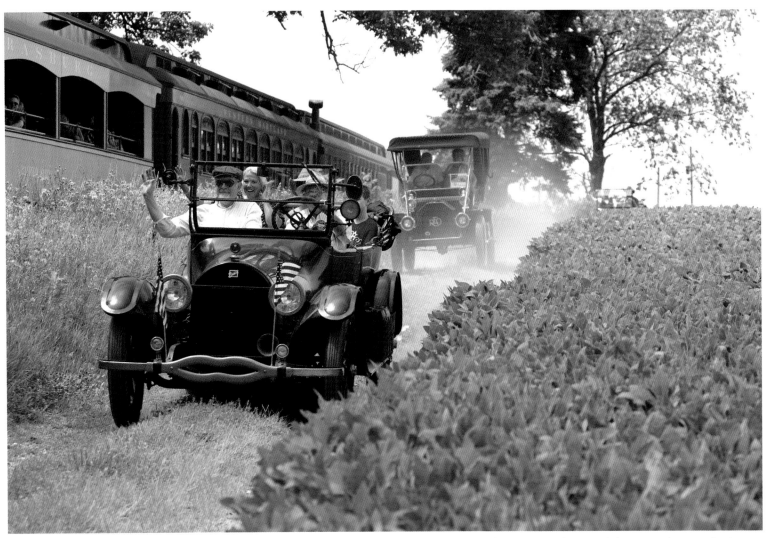

The Strasburg Rail Road is the oldest continuously operating shortline railroad in America. Among the special events they run is the Great Train Race, where antique vehicles drive along the side of the train.

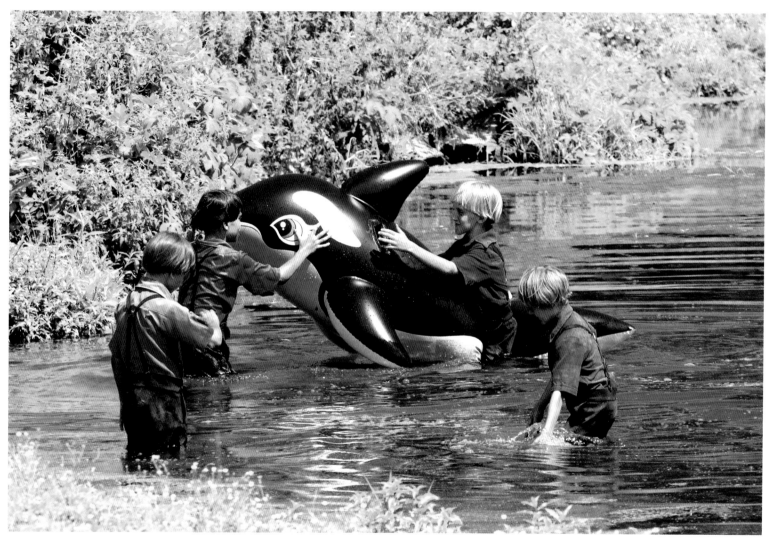

Summertime temperatures can rise to the mid-90s and above. On this hot July day, these four Amish boys take a swim in a local stream.

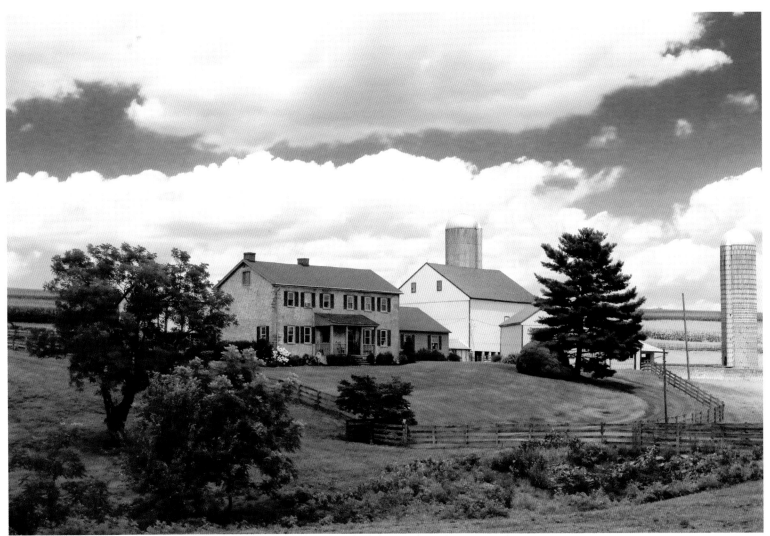

A scenic farmstead located on the rolling Susquehanna River hills in southern Lancaster County

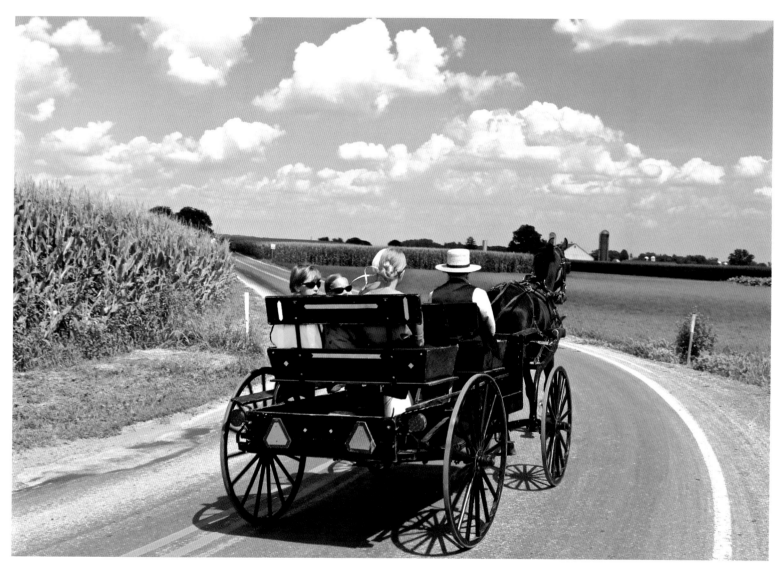

An Amish family heads home after a day of activities in eastern Lancaster County.

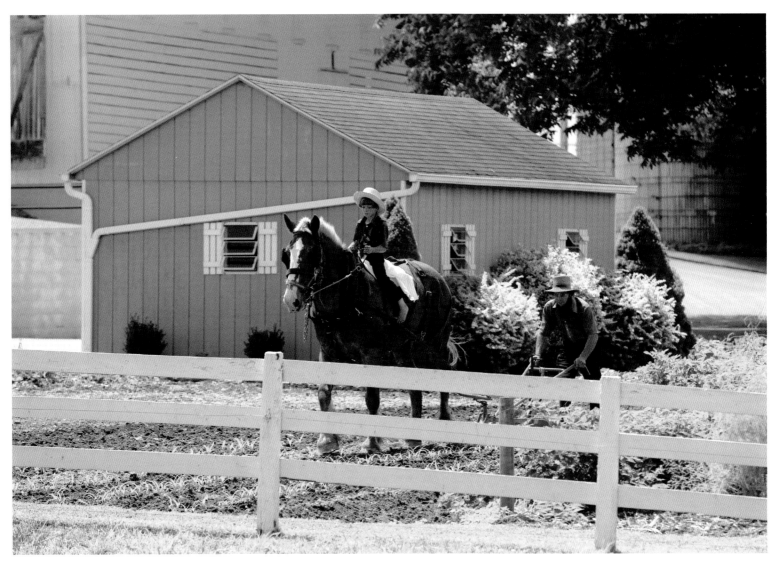

A young Amish lad guides a horse through the garden as Dad follows behind, controlling the plow.

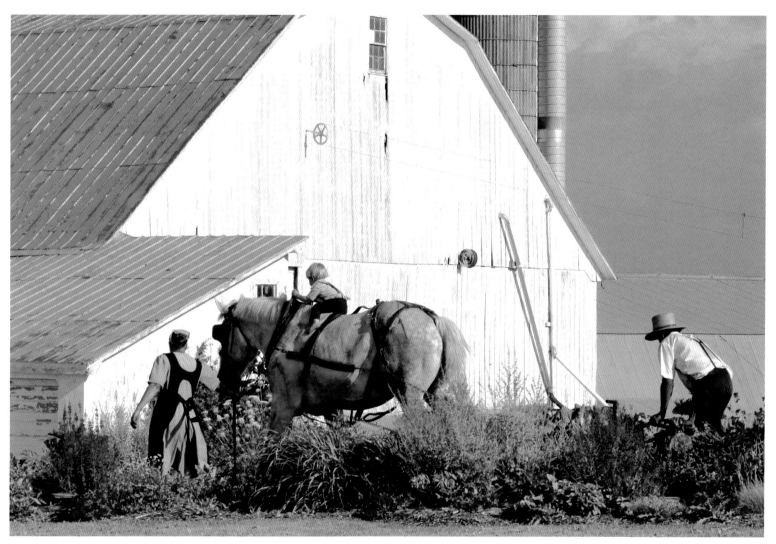

Mom leads the horse as her young son hangs on tightly. Dad mans the plow.

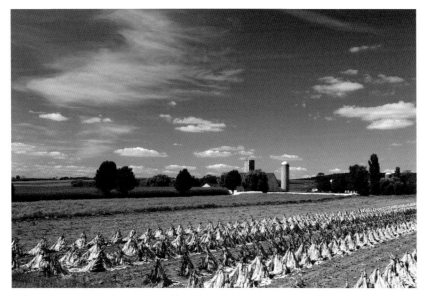

A farm in eastern Lancaster County

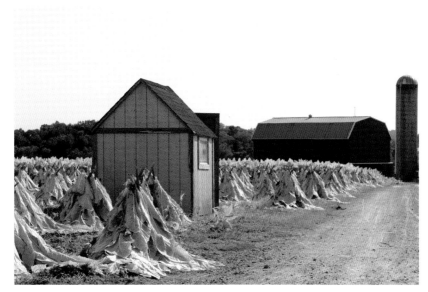

Tobacco is neatly stacked

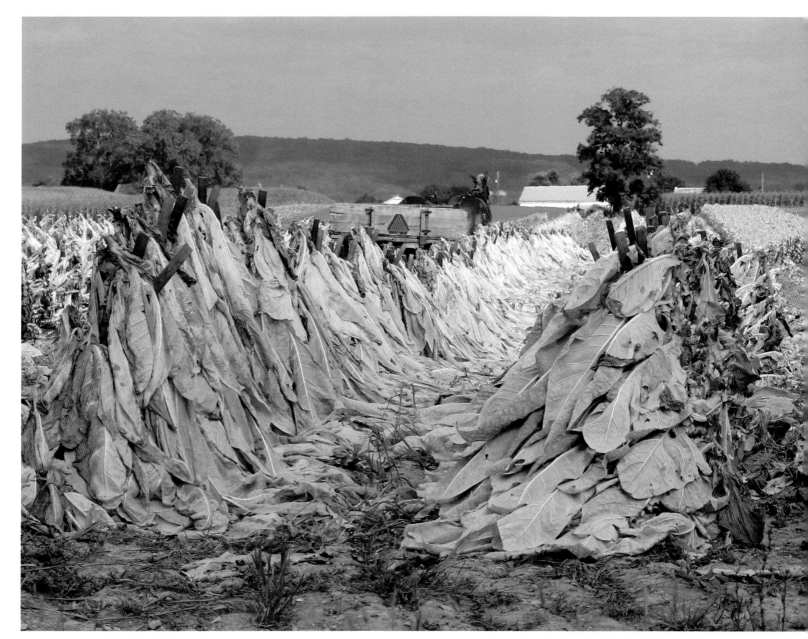

Tobacco is speared onto lath and stacked, waiting to be transported to the shed to be hung.

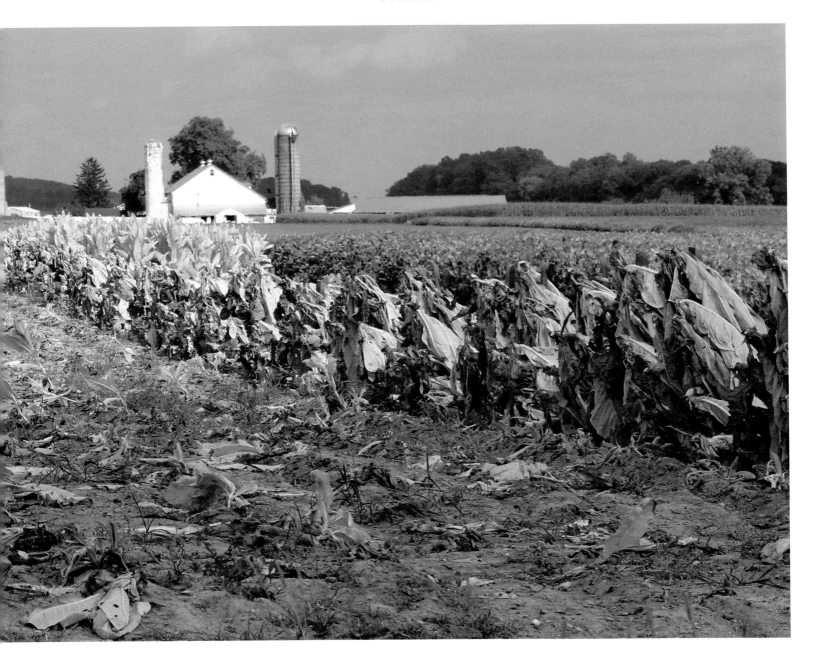

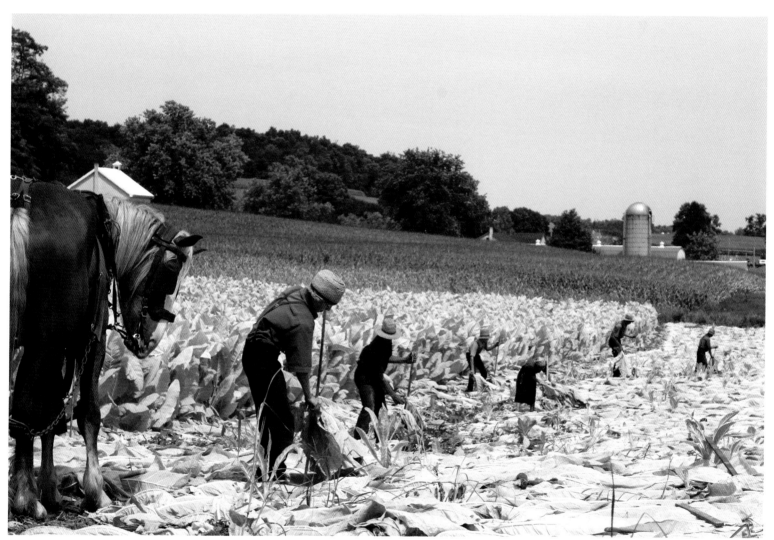

An Amish family spears tobacco, which will be loaded onto wagons.

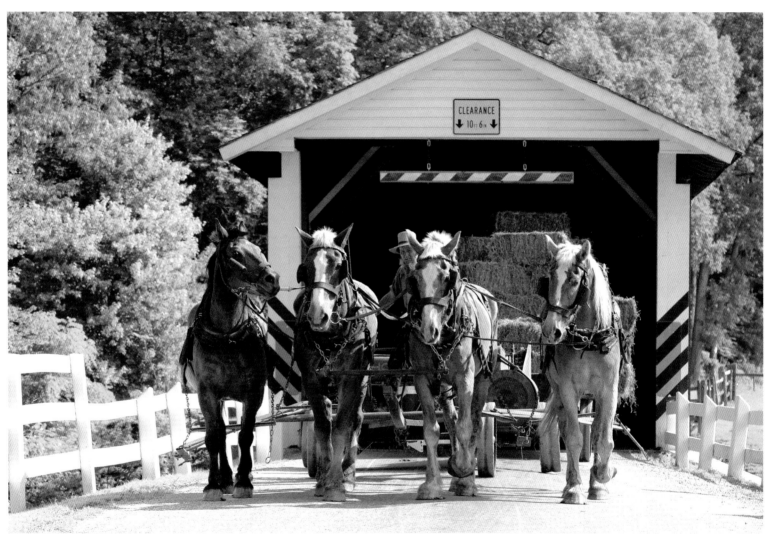

It is a tight squeeze, but this Amish farmer brings his horse-drawn baler and wagon through the Jackson's Mill covered bridge.

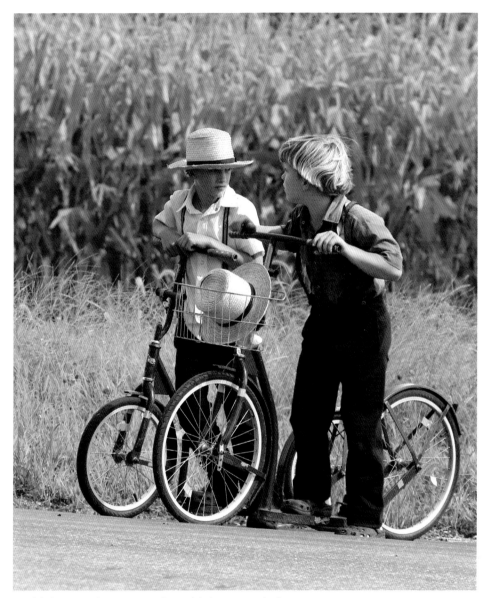

Amish boys wait to cross a busy highway on their scooters.

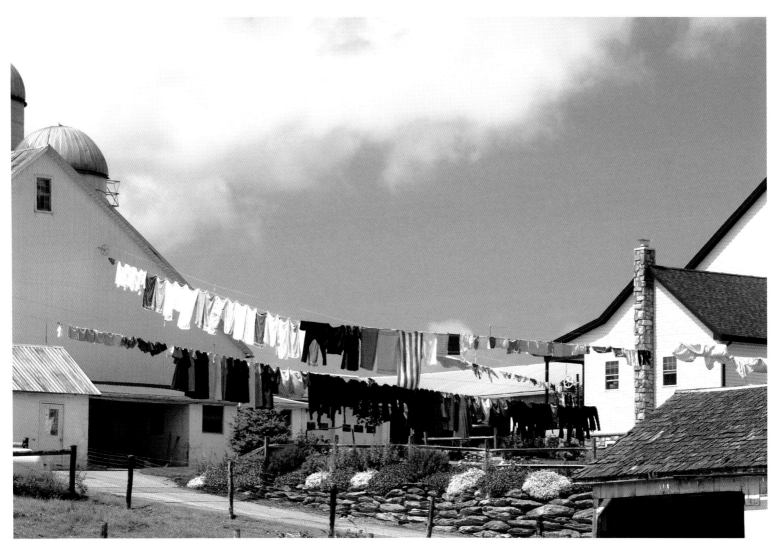

A typical scene in Lancaster County: colorful wash hung on a "solar dryer"

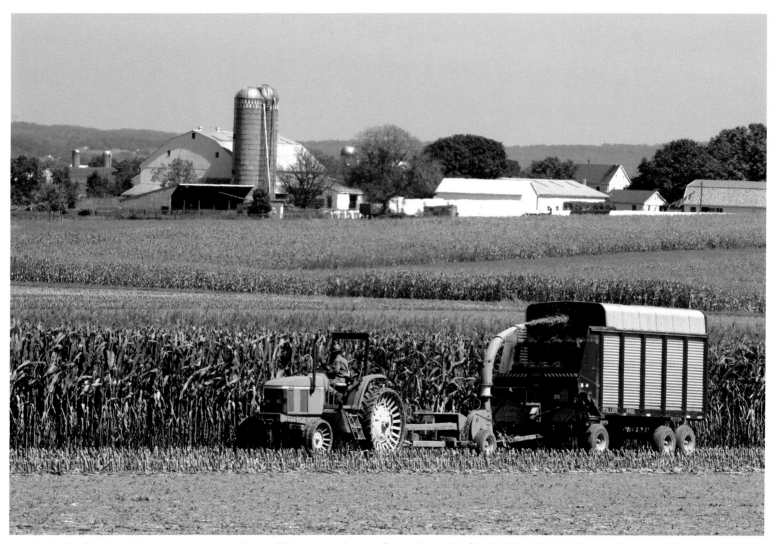

A Mennonite farmer cuts and chops corn that will be blown into a silo and used to feed cattle during the coming months.

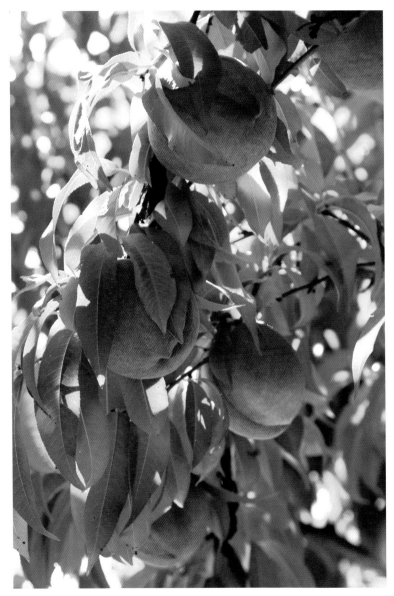

Delicious peaches ripen in mid- to late summer and are a favorite fruit of locals, who both eat them fresh and can them.

Fall

As summer slowly fades away, subtle hints of fall arrive. The leaves begin to change color, cooler evenings invade the county, and frosty mornings cover the landscape.

Harvest time continues in full force, as the crops need to be put away before winter's snow blows. It is a time for pumpkins, corn shocks, and giving thanks.

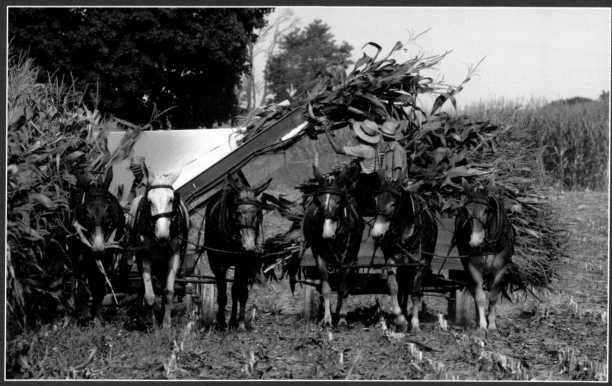

Amish farmers cut and load corn.

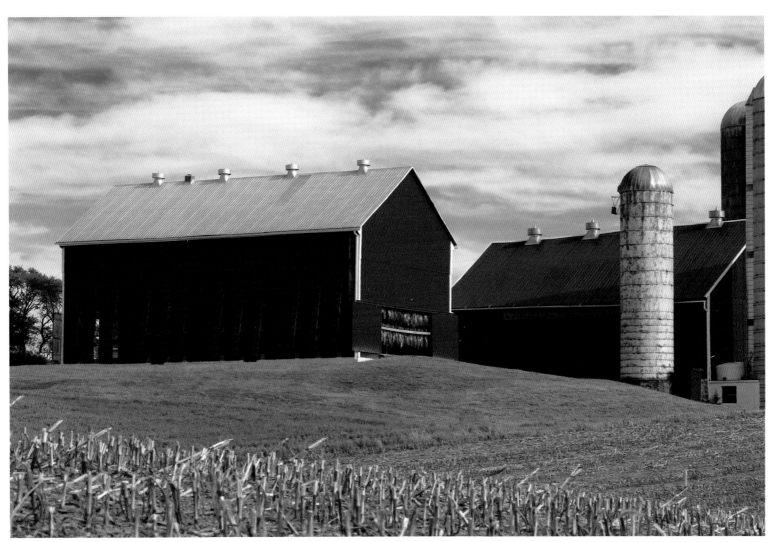

Recently harvested tobacco is hung in the shed to dry. The slats on the side of the shed are open to provide ventilation.

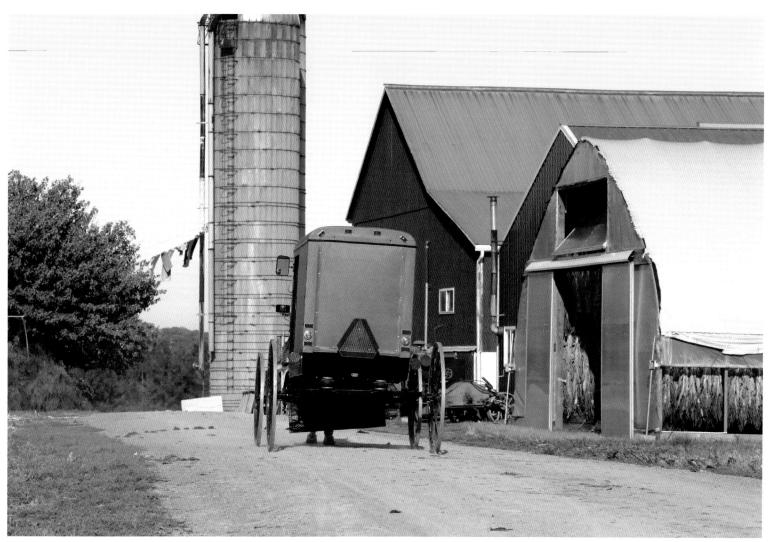

An Amish buggy returns home after a short trip.

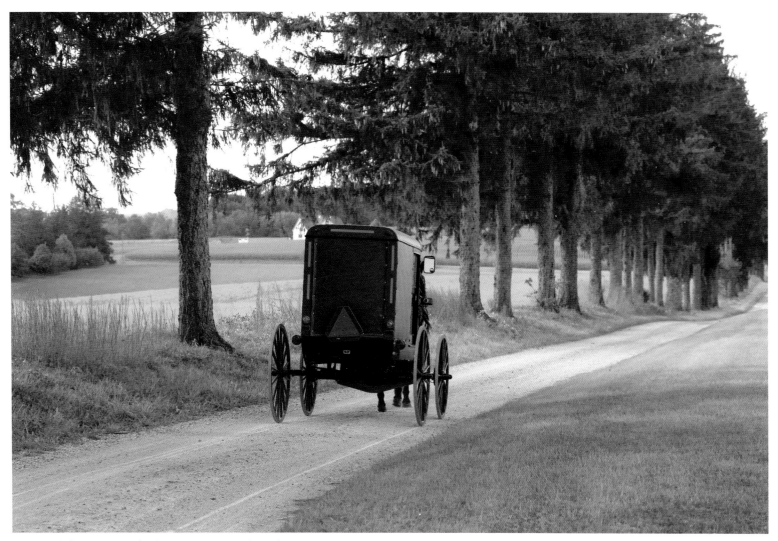

An Amish buggy travels along an unpaved road in southern Lancaster County.

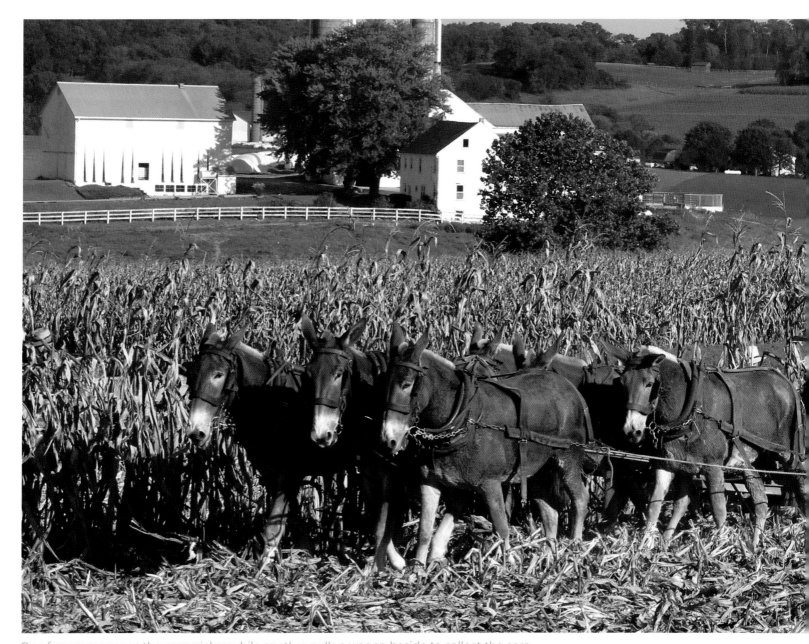

One farmer manages the corn picker while another pulls a wagon beside to collect the ears.

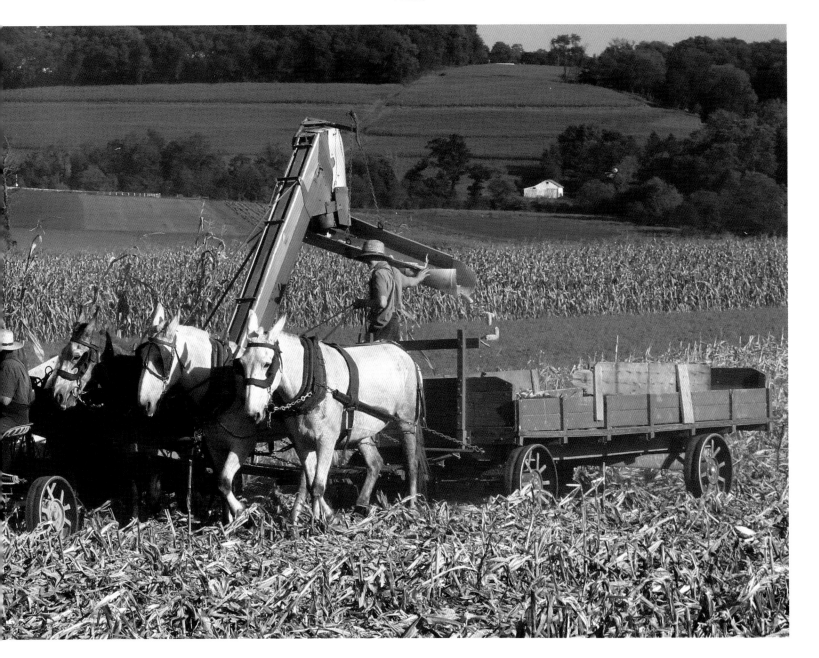

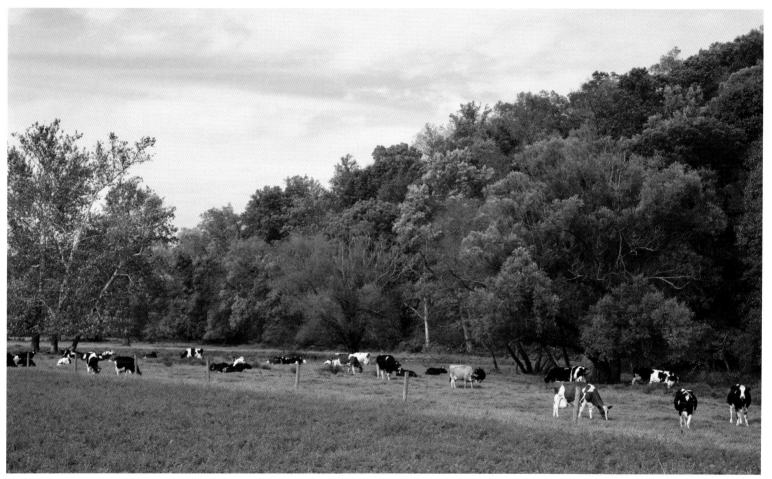

Cows graze contentedly in their pasture on a beautiful fall day. Lancaster County is the top milk-producing county in the state, and the eighth largest in the United States.

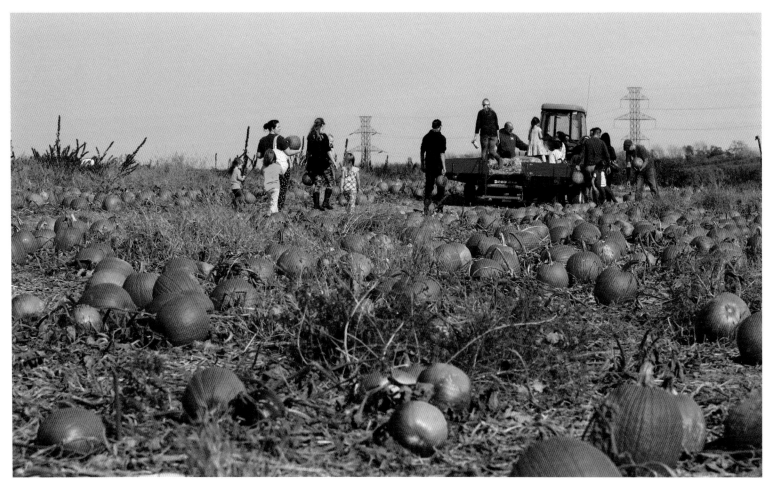

A number of farms provide hayrides to self-pick pumpkin patches.

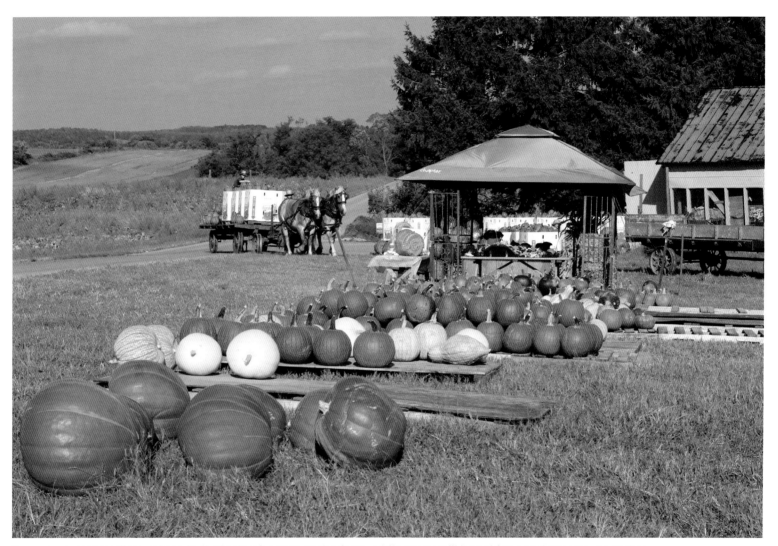

Some pumpkins will be sold to individuals who stop at the farm, while many will be sold to vendors who resell them.

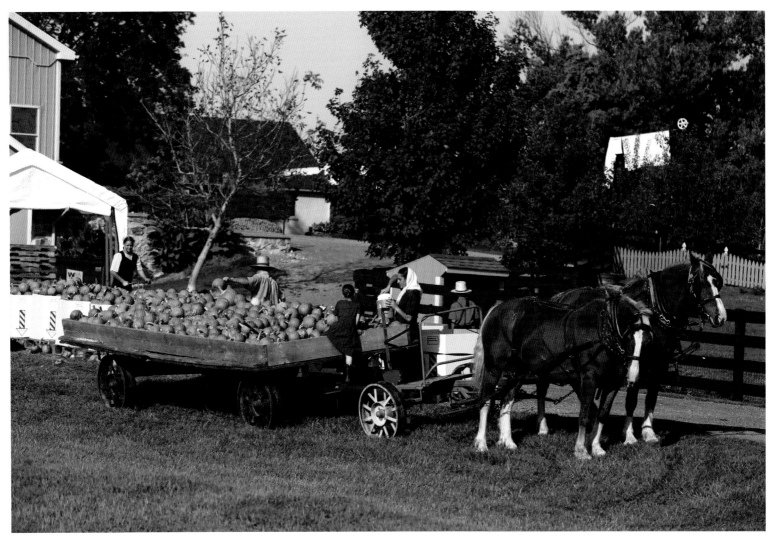

A load of pumpkins just arrived at this roadside stand along a busy road in eastern Lancaster County. The whole family is involved in harvesting and selling the pumpkins.

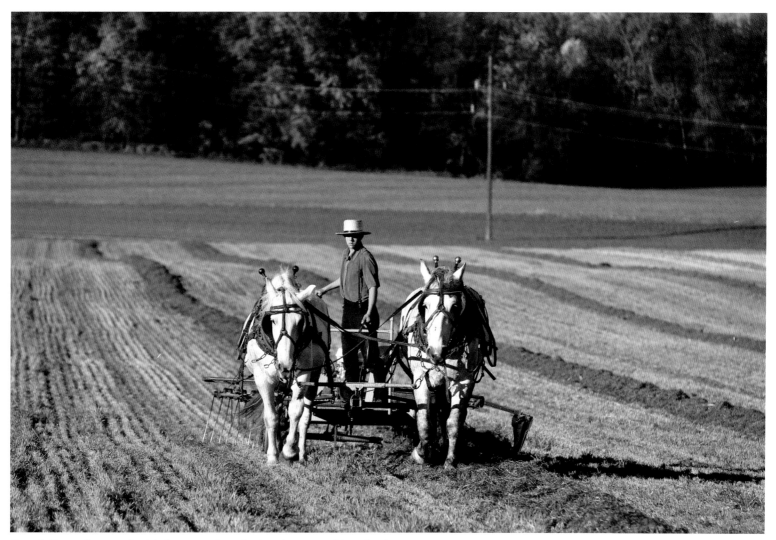

On a fall evening, an Amish farmer rakes the last harvest of hay for the season.

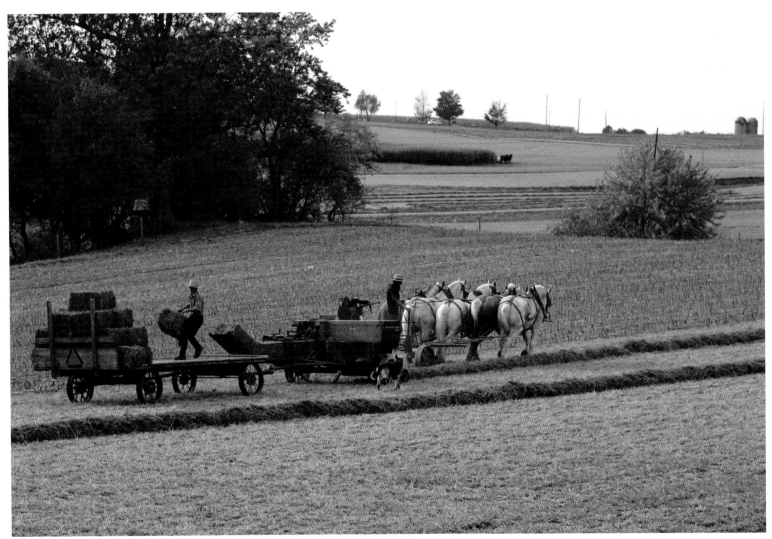

The final hay harvest of the year being baled and loaded on a wagon

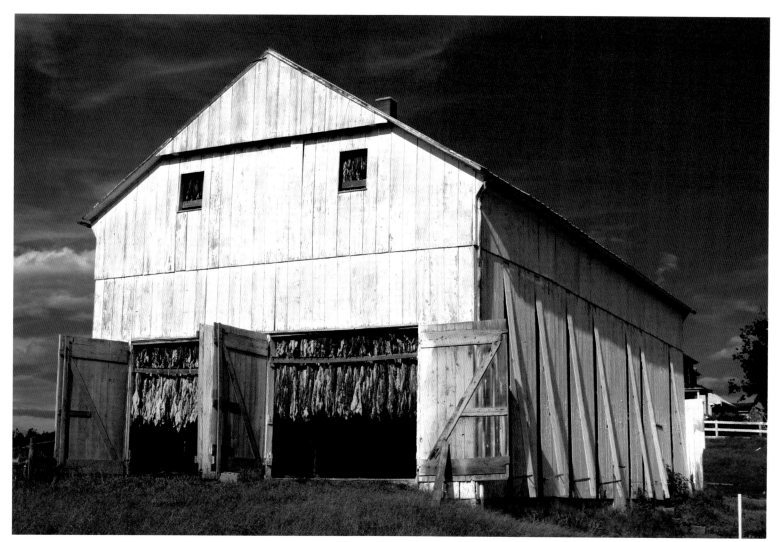

A shed filled with drying tobacco

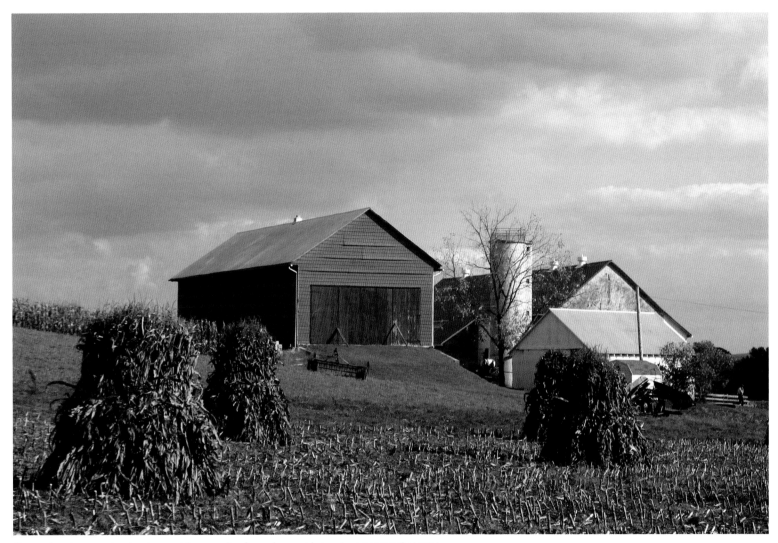

Corn shocks are stacked on a Mennonite farm in northern Lancaster County.

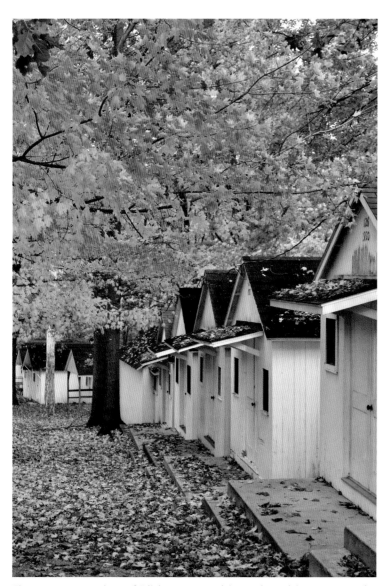

There are a number of Bible camps with quaint white cottages in Lancaster County. This one is in the western side of the county.

Colorful leaves accent an old red barn's window.

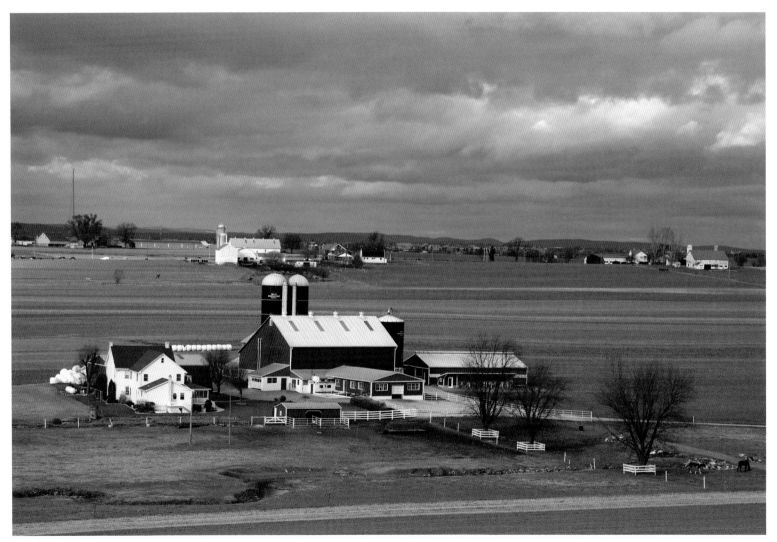

Perhaps the most photographed farm in Lancaster County. It is located in an area known by locals as "Grasshopper Level."

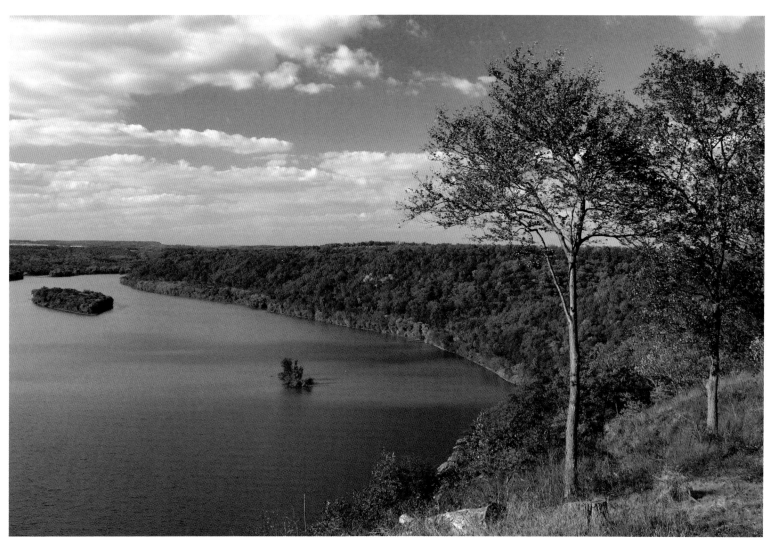

View of the Susquehanna River from the popular Pinnacle Point overlook in southwestern Lancaster County

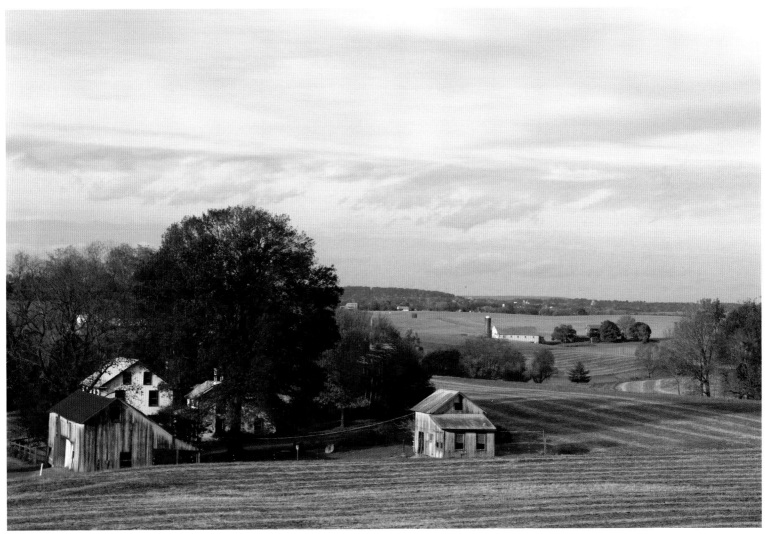

The rolling hills along the Susquehanna River. The crops have been stored in anticipation of the coming winter months.

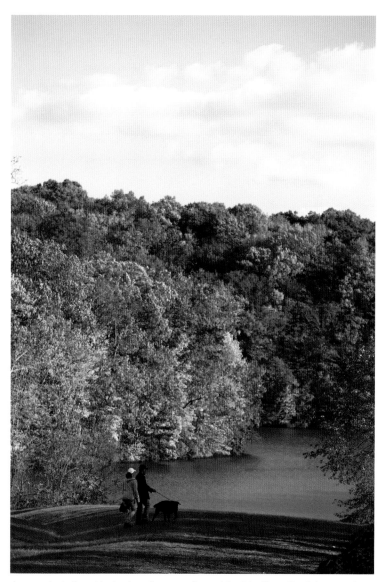

A couple takes their dog for a walk at Muddy Run Park in southern Lancaster County.

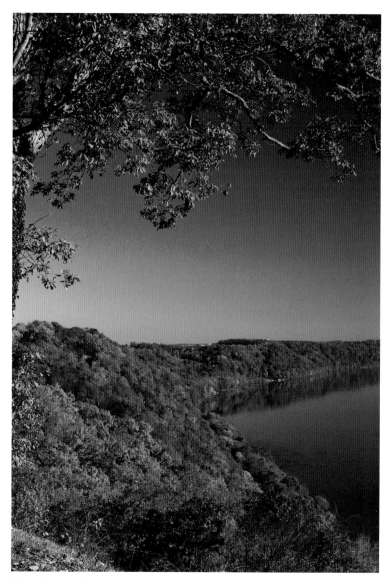

The view looking south from Susquehannock State Park in southwestern Lancaster County. The Susquehanna River forms the western edge of Lancaster County.

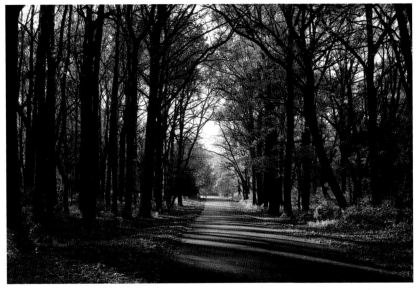

The sun is setting behind the tree-lined entrance road to Susquehan-
nock State Park.

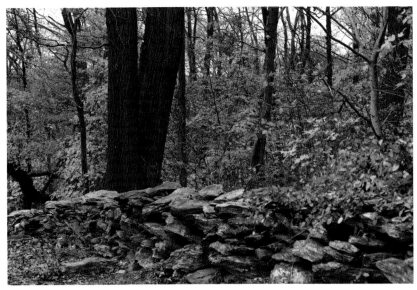

A stone wall runs along a ridge at the Pinnacle Point overlook.

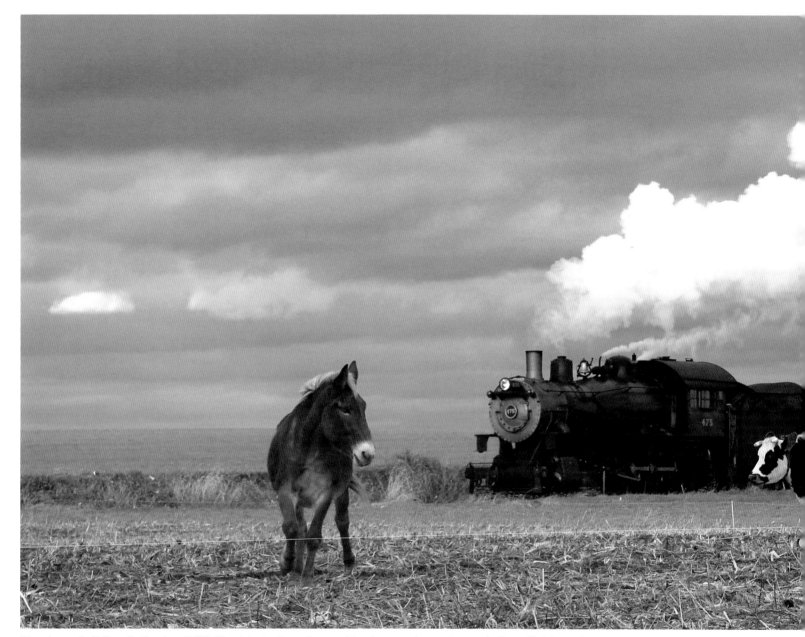

Strasburg Rail Road's Engine #475. The trip to Paradise and back goes through scenic farm fields and pastures.

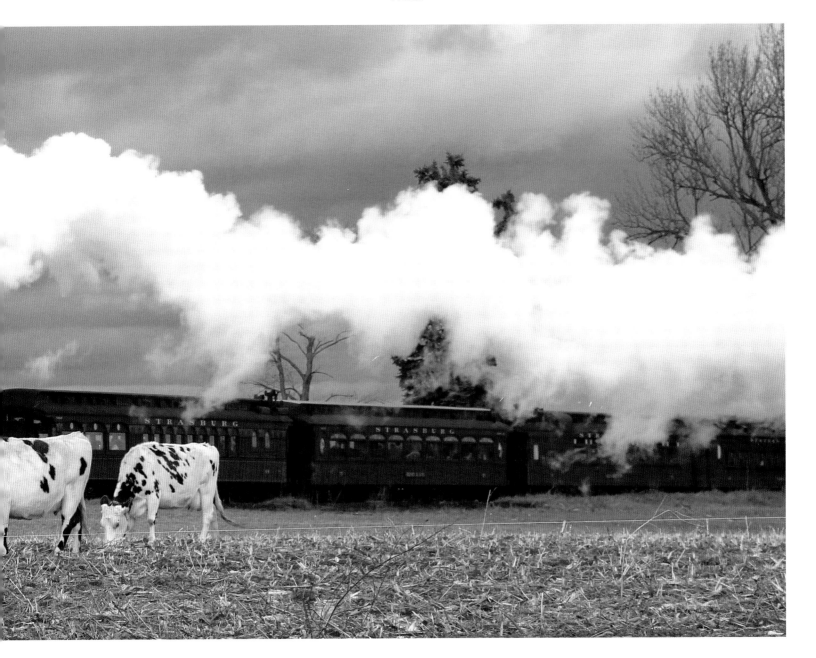

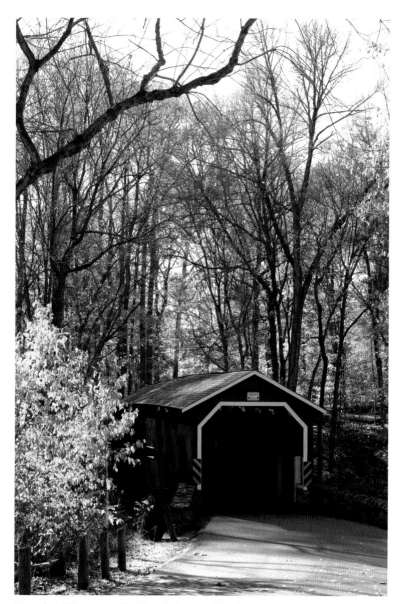

Kurtz's Mill covered bridge is located in the county park just south of Lancaster. Lancaster County has the most covered bridges of all of Pennsylvania's counties.

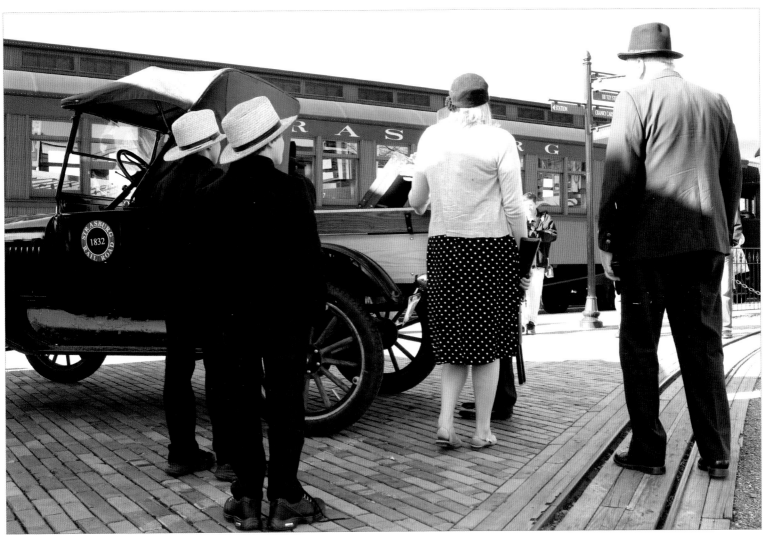

Two Amish boys enjoy the closing action of the "Great Train Robbery" event held several times a year at the Strasburg Rail Road.

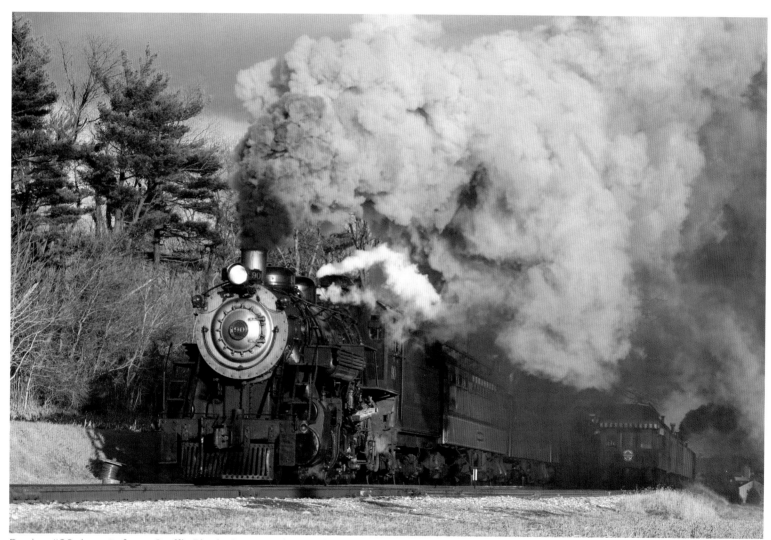

Engine #90 departs from Groff's Picnic Grove as the eastbound train continues to Paradise in early December.

Winter

As fall is overtaken by winter, dancing snowflakes fall from the gray winter clouds. Nights are cold and long, beckoning us to rest and rejuvenate.

Snow-covered fields provide a time of quiet and calm. It is a time for sledding, ice skating, or a horse-drawn sleigh ride.

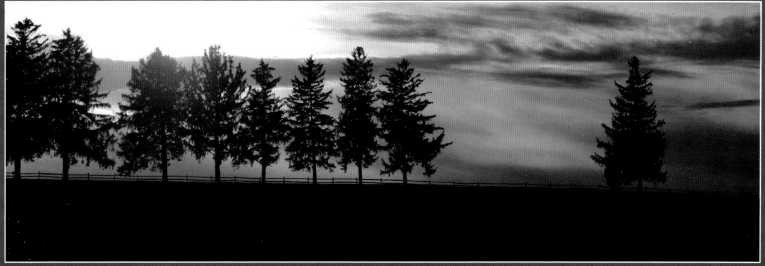

The sun sets behind a row of evergreen trees along a fence line.

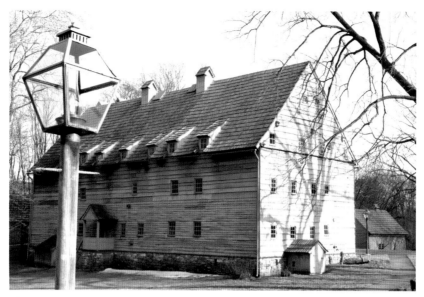

The Ephrata Cloister Museum in northern Lancaster County is a popular destination in the winter season.

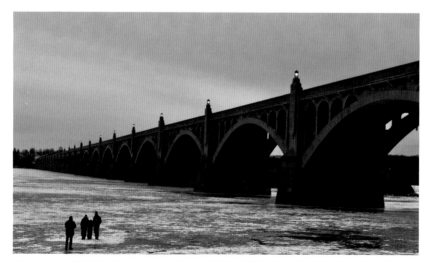

The Route 462 bridge as seen from Columbia Crossing in the historic river town of Columbia. In the foreground, people venture onto the ice of the frozen Susquehanna River.

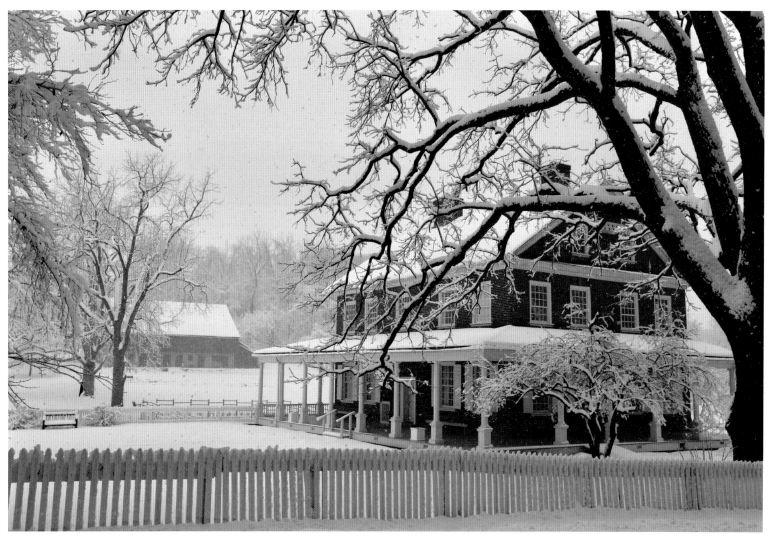

Rock Ford Plantation is located in Lancaster County Park. It is the eighteenth-century home of Edward Hand, adjutant general to George Washington during the Revolutionary War.

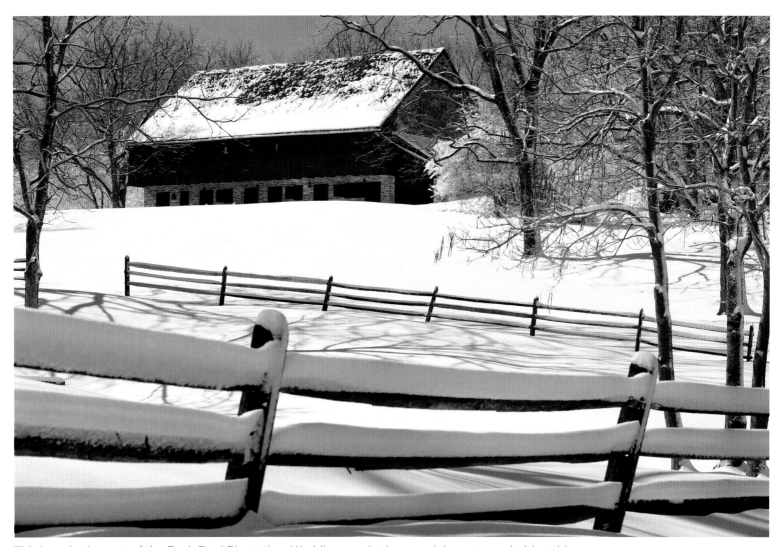

This barn is also part of the Rock Ford Plantation. Weddings and other special events are held at this venue.

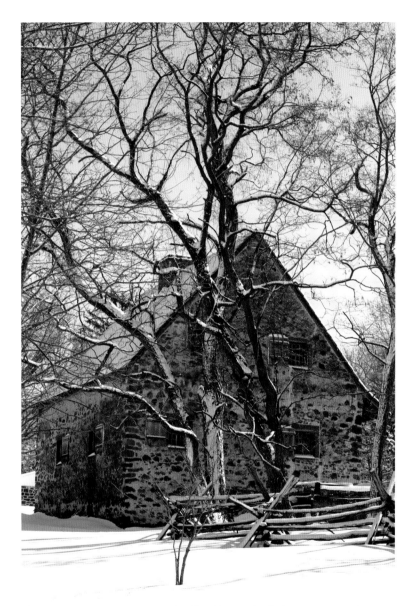

The Hans Herr House was the first house built in Lancaster County.
It was built in 1719 by Christian Herr and is now a restored historic
house located south of Lancaster.

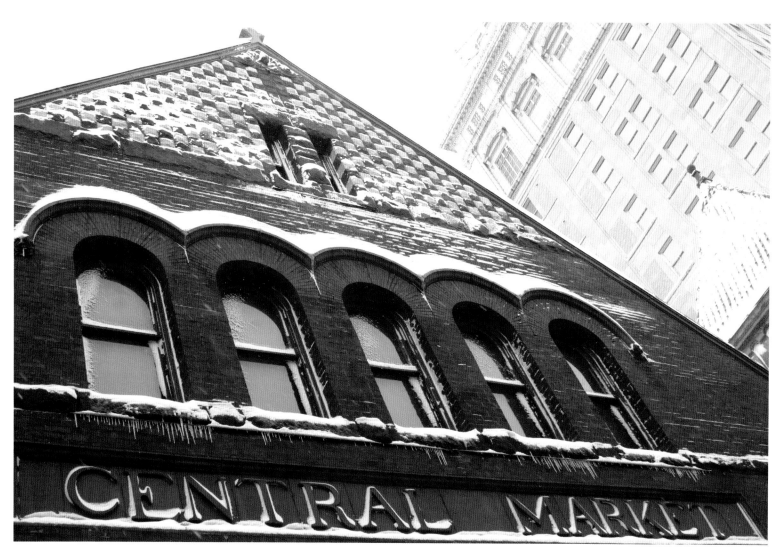

Central Market in downtown Lancaster. The red-brick building, built in 1889, is full of character and history.

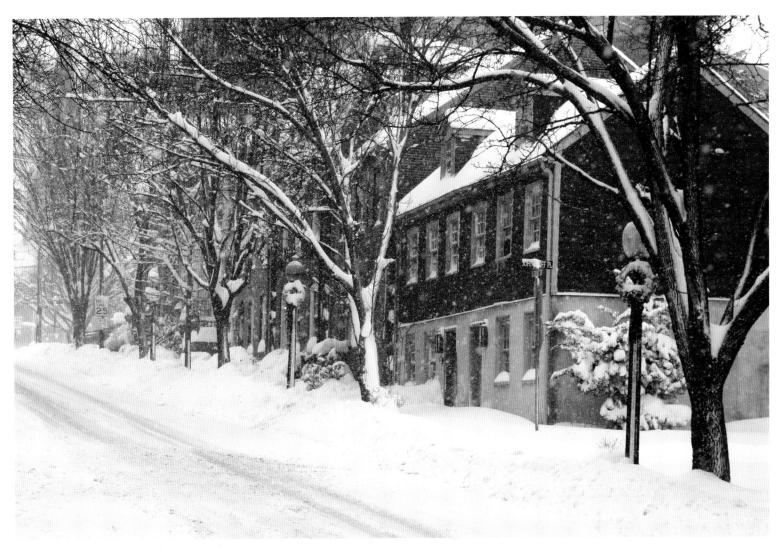

A beautiful snowy day in downtown Lancaster

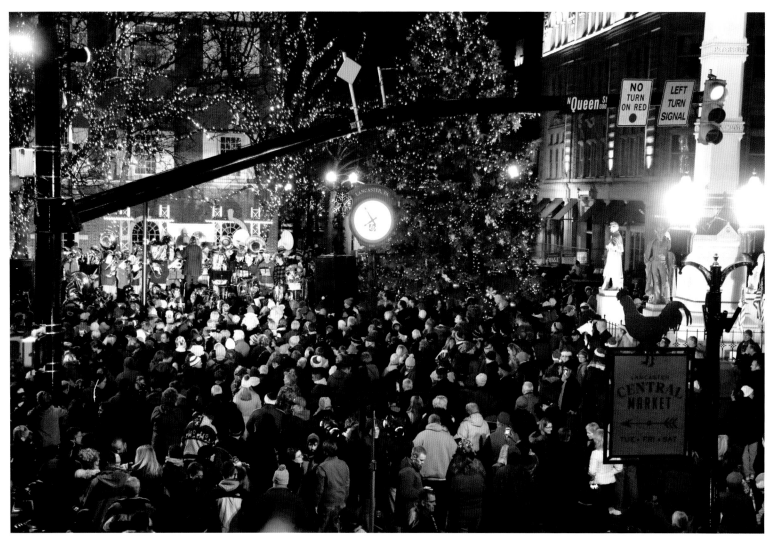

The annual Tuba Christmas is held in Lancaster's Penn Square and includes the lighting of the Christmas tree, the arrival of Santa, and the popular tuba concert.

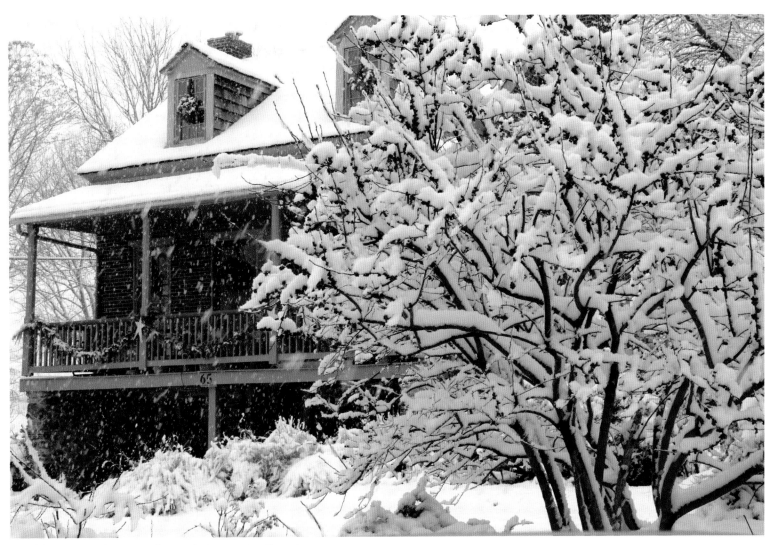

An older restored country home in Lancaster County

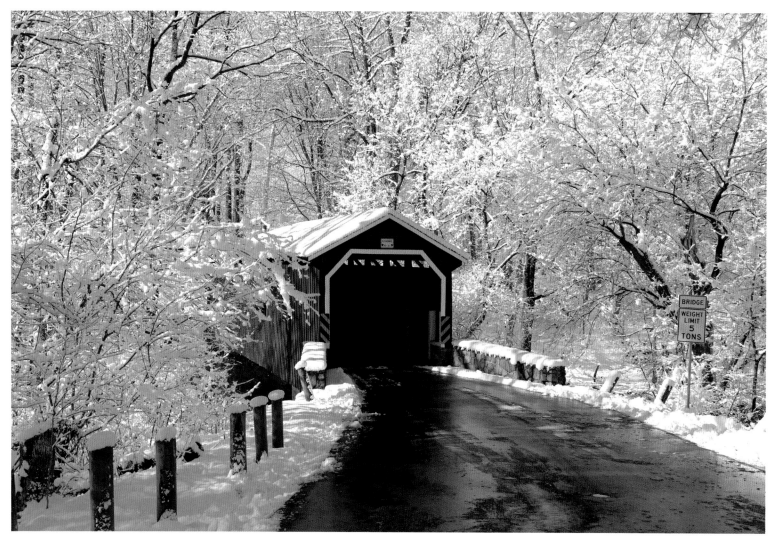

The Kurtz's Mill covered bridge in Lancaster County Park the morning after a fresh snowfall

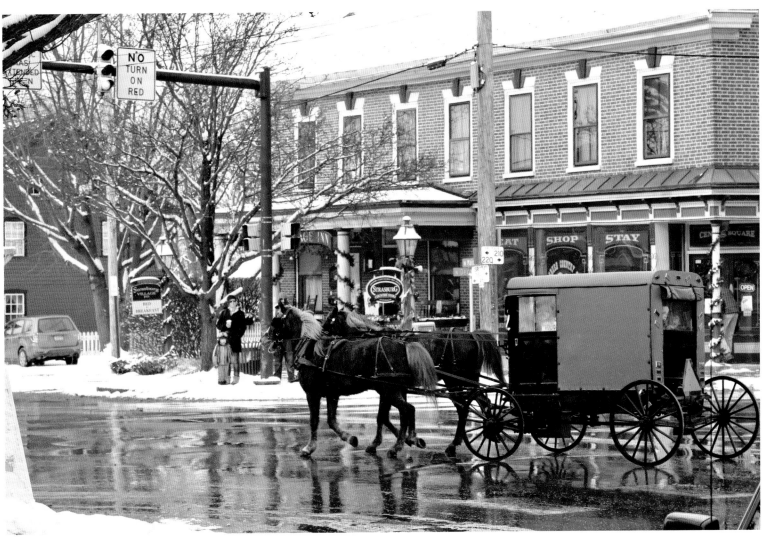

A two-horse closed buggy travels through the square of historic Strasburg. Take note of the children peering out rear window.

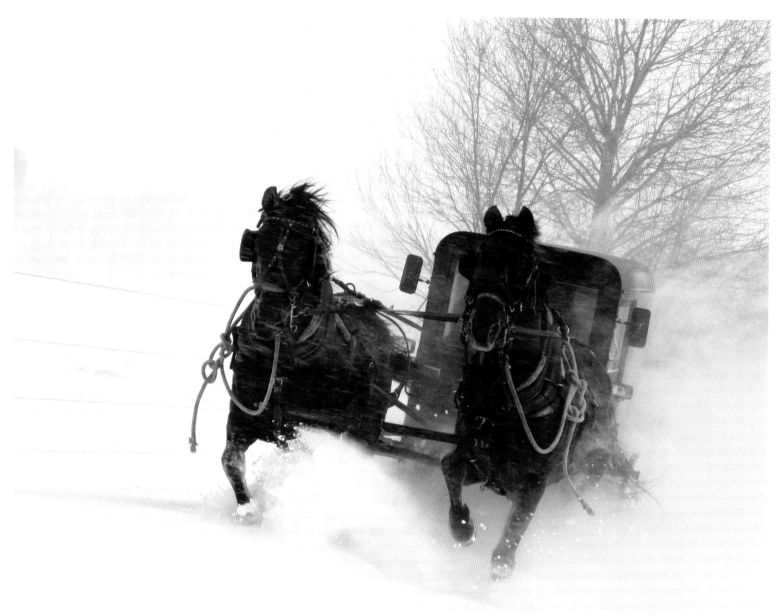

A two-hitch Amish buggy drives out of a snow drift on a cold winter day.

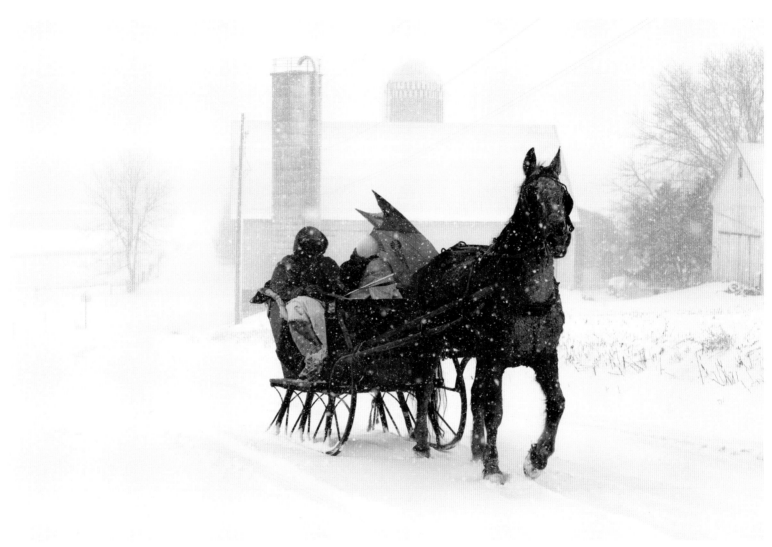

A one-horse open sleigh slides through the snow on a country road.

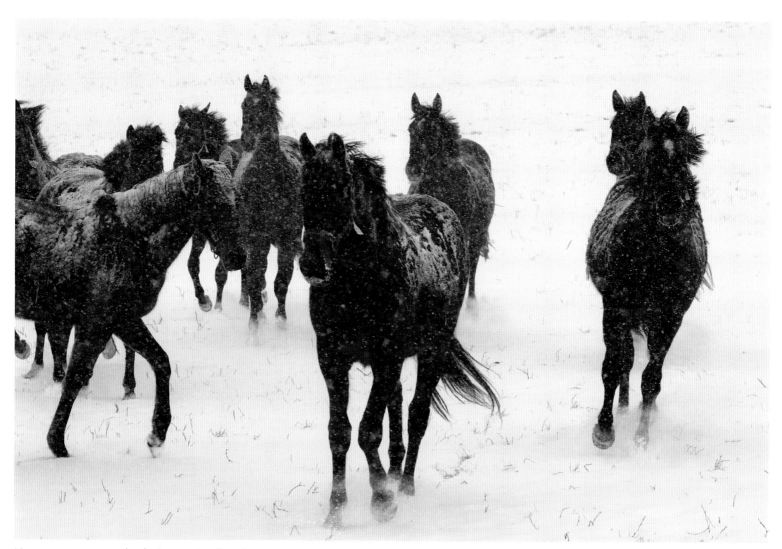

Horses on a snowy day in Lancaster County

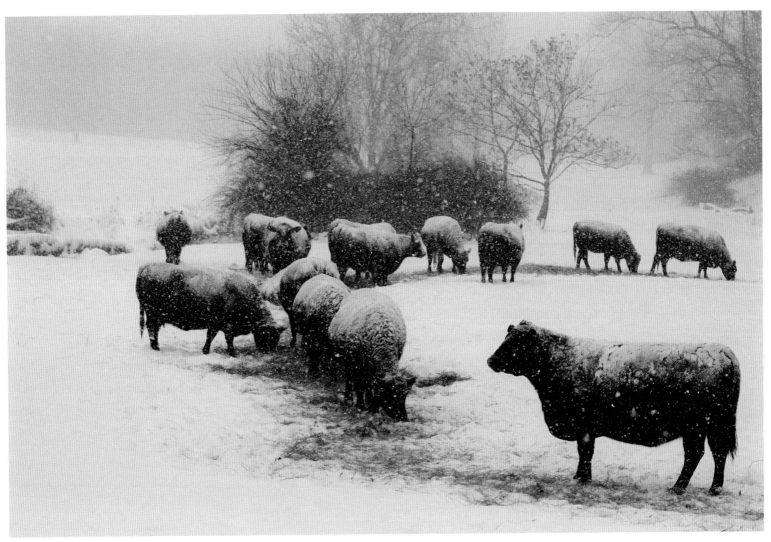

Angus cattle eat hay provided by the farmer on a snowy day.

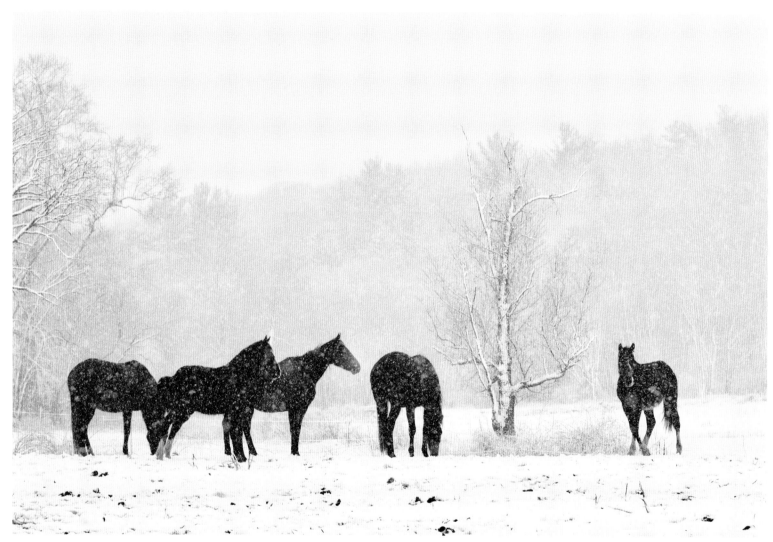

Horses roam the pasture.

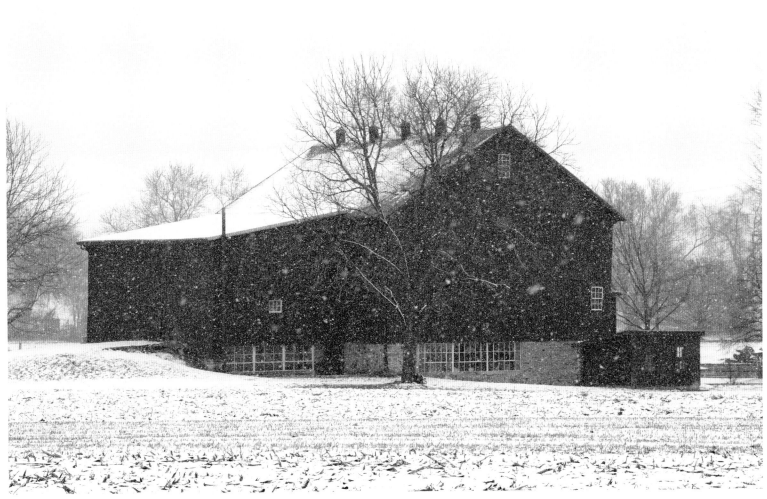

A red barn on a snowy day

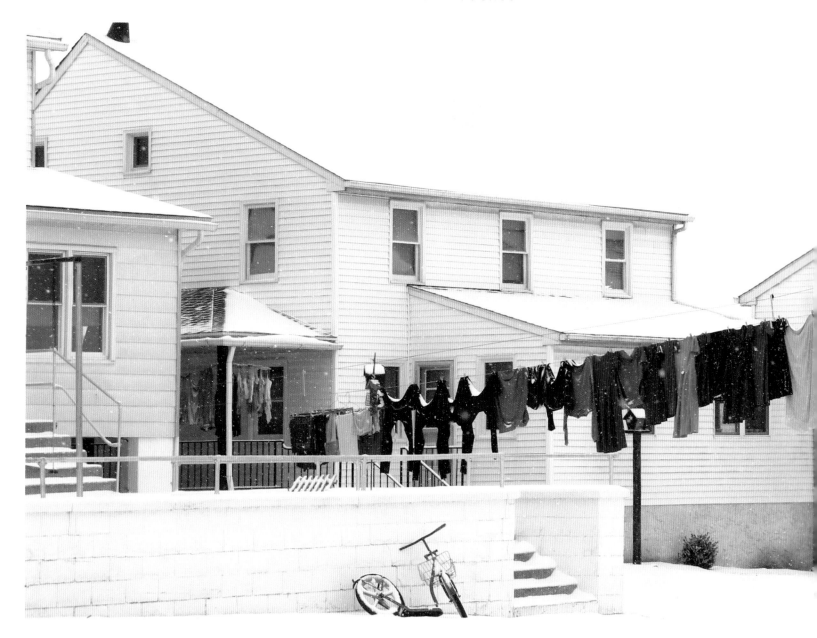

Wash hung on the line to dry

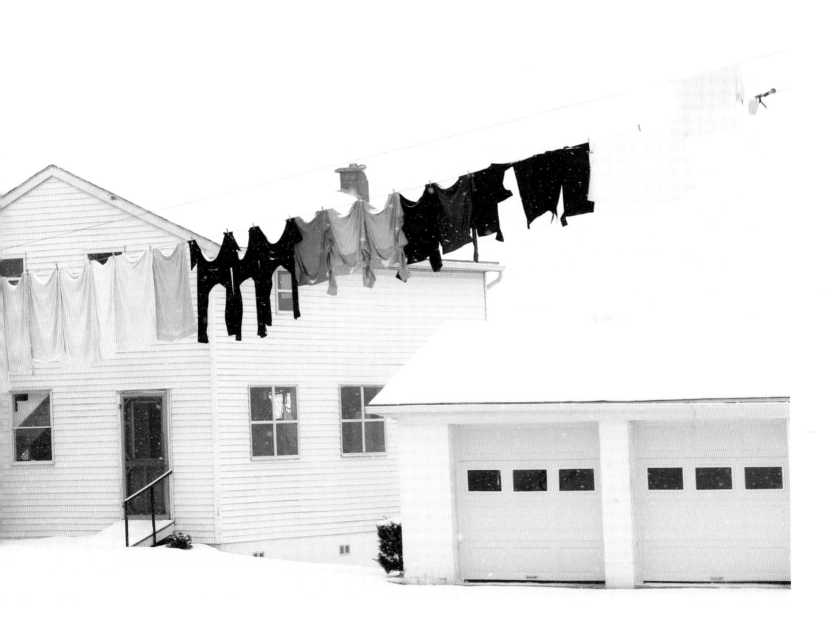

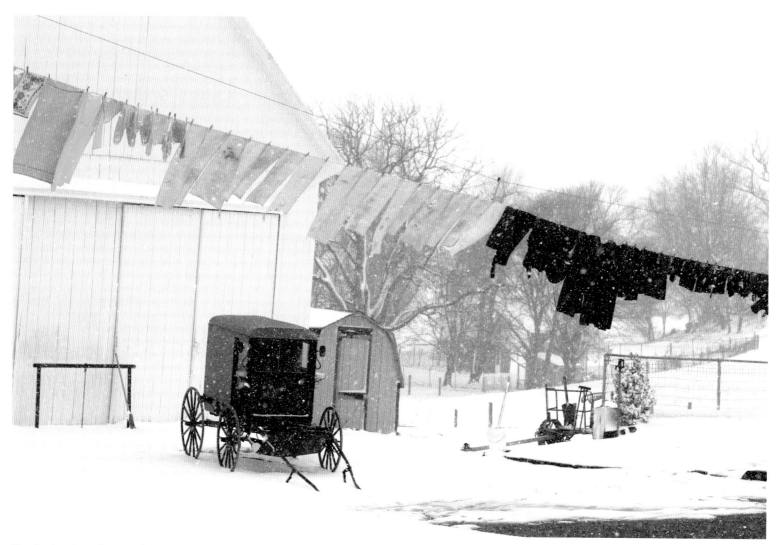

The "solar dryer" at work on an overcast snowy day

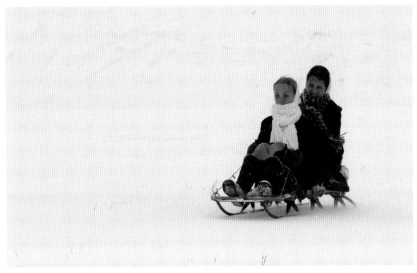

At recess, Amish children sled and play while supervised by their teacher. The Amish attend school through eighth grade.

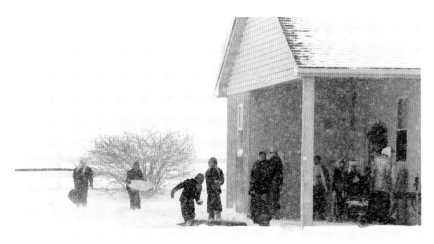

Amish students gather outside their one-room schoolhouse at the end of the school day. Most will walk home.

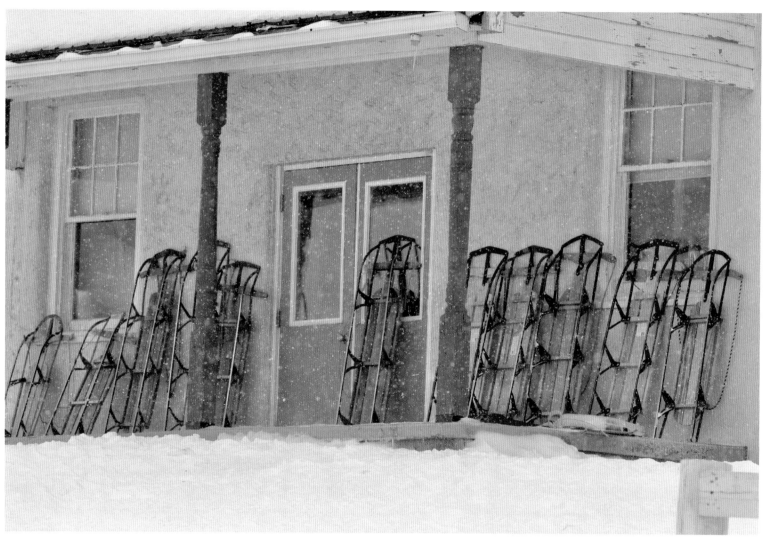

Sleds on the porch of a one-room schoolhouse

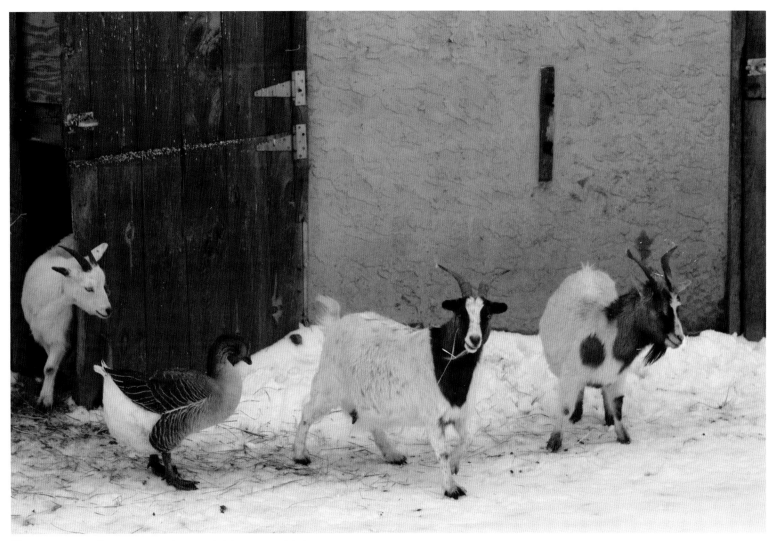

Three goats and a goose venture outside on a cold day.

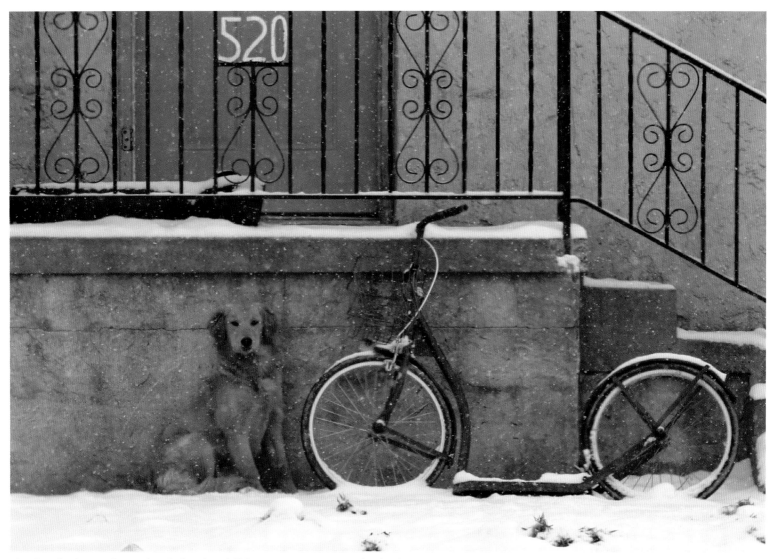

The family dog waits patiently for the children to come out to play in the snow.

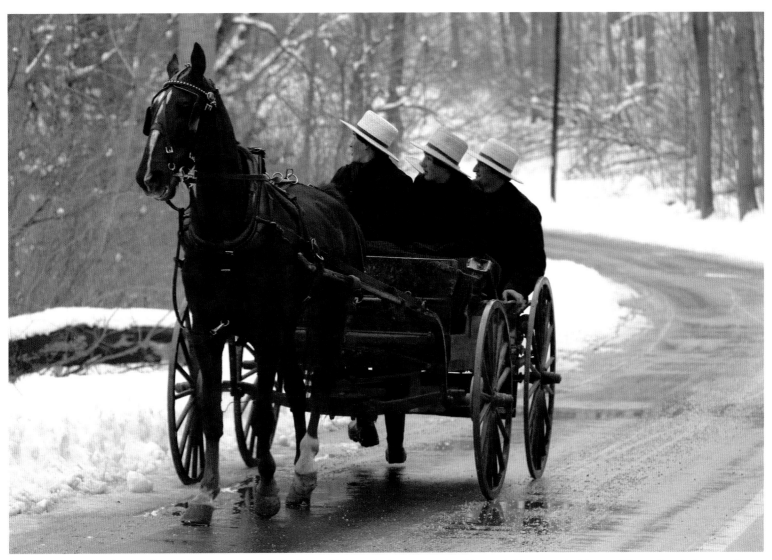

These young Amish men intently watch a herd of whitetail deer that are roaming through the woods. Many of them hunt deer and freeze the venison.

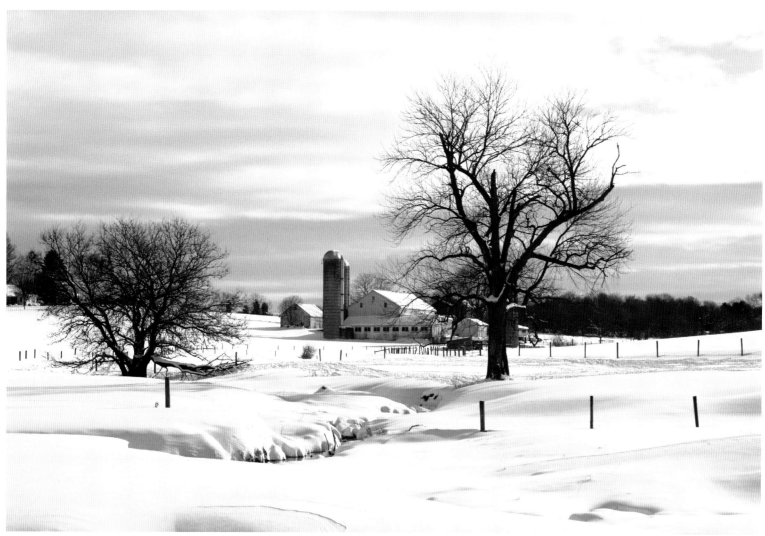

A classic winter farm scene in Lancaster County

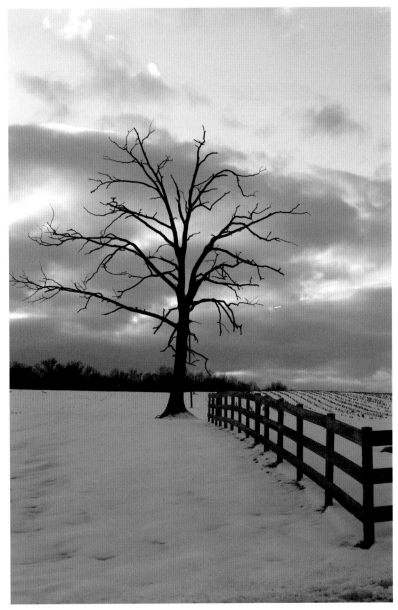

A lone, barren tree at the end of a fence row

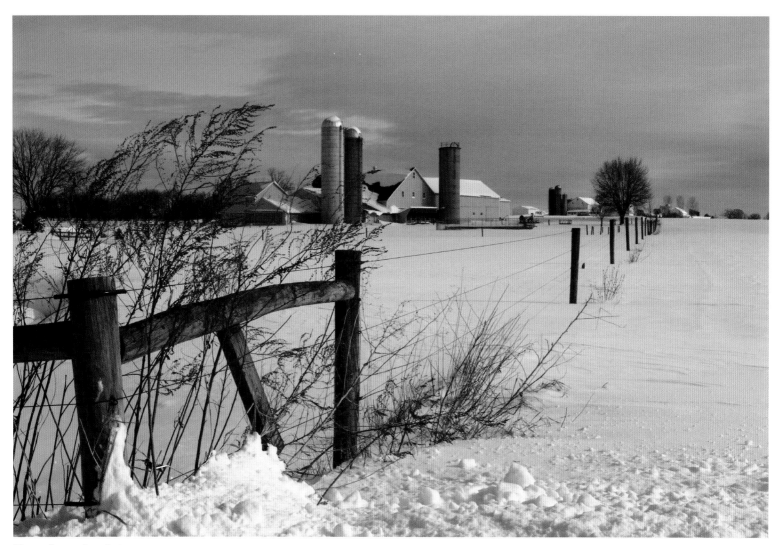

Three farms in winter

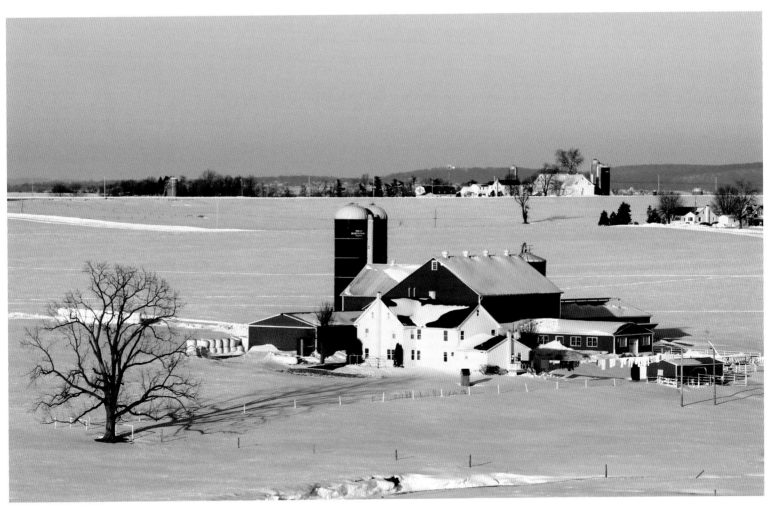

A farmstead nestled in a scenic valley, typical of many Lancaster County farms

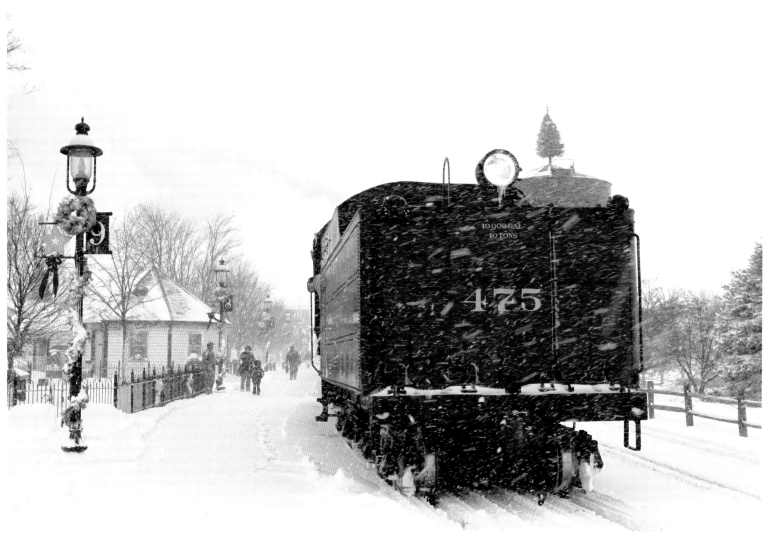

Passengers waiting to board a steam-powered train

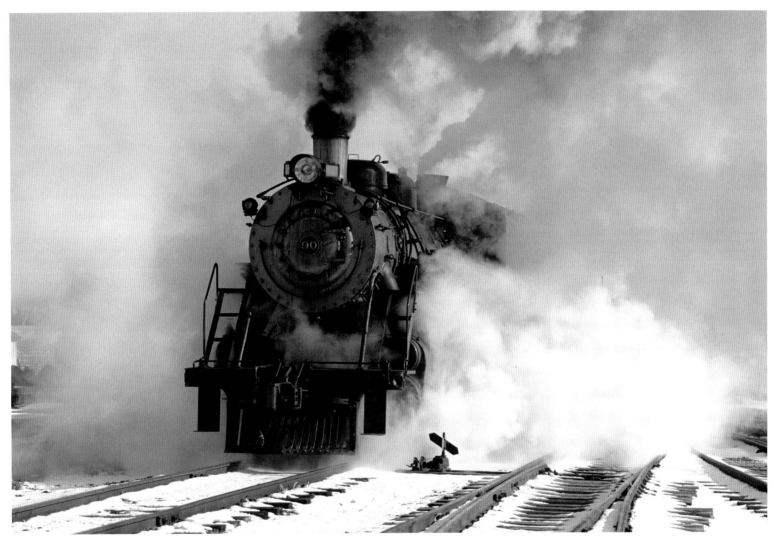

Engine #90 preparing for the day's duty of taking passengers to Paradise and back

Image courtesy of Jeremy Hess Photography

Don Shenk is a lifetime resident of Lancaster County, Pennsylvania, and has been a photographer for more than five decades. He is a lifetime member of New Danville Fire Company, where he is still active as a firefighter/photographer. He also uses his skills at Central Manor Church, which he has attended all his life. Don was a charter member of the Lancaster Camera Club and has served as its president twice. In 2016, he was made Senior Fellow of WIEP (Wilmington International Exhibition of Photography), a distinction given to the select few who have had more than a hundred entries accepted into the juried international show. He is known locally for his exceptional work documenting the region's iconic scenery, including the Amish lifestyle.